C000136925

SHOOT
LIKE A
NINJA

'This is a must-read book for photographers of all levels and genres. A practical, relevant and timely chronicle for photographers who want to succeed in business. Chris and Yuan know their stuff. Photographers: Buy this book, devour it, and follow the advice. Your business will thank you for it!'

ALEX CEARNS OAM,
Founder of Houndstooth Studio and winner of over 350 awards
for business, philanthropy and animal photography

'*Shoot Like a Ninja* is a fantastic blueprint for any modern wedding or portrait photographer to employ and level their business up. The steps are super clear and clever – I love the offline as well as online strategies that you can implement with minimal effort and maximum reward. Chris's real-world experience as a busy working photographer is a bonus and makes me think that if he can have a successful career AND be the boss at Studio Ninja, then these methods must be utterly killer!'

LISA DEVLIN
Award-winning photographer and founder of Photography Farm

'WOW! Photographer, no matter where you're based or what you shoot, you need to read this book if you want to see improvements in your business. Whether you're new to making money from photography or have been shooting for twenty years or more – there's no way you're walking away from the info in this book and not feeling motivated to be better. If things are going great for you, don't use that as an excuse to skip this book. You'll be challenged to look at your business and what you're doing from different perspectives, which can only help if you're looking to be better. A ton of gold nuggets in this one. Get it, read it, implement... then read it again!'

ANDREW HELLMICH
AIPP Master Photographer and host of PhotoBizX podcast

Shoot Like a Ninja: 4 steps to work less, earn more and superpower your photography business

Copyright © 2021 by Chris Garbacz and Yuan Wang.
All rights reserved.

Published by Grammar Factory Publishing, an imprint of MacMillan Company Limited.

No part of this book may be used or reproduced in any manner whatsoever without the prior written permission of the author, except in the case of brief passages quoted in a book review or article. All enquiries should be made to the author.

Grammar Factory Publishing
MacMillan Company Limited
25 Telegram Mews, 39th Floor, Suite 3906
Toronto, Ontario, Canada
M5V 3Z1

www.grammarfactory.com

Shoot Like a Ninja: 4 steps to work less, earn more and superpower your
 photography business / Chris Garbacz and Yuan Wang.

Paperback ISBN 978-1-98973-742-2
eBook ISBN 978-1-98973-743-9
Audiobook ISBN 978-1-98973-744-6

1. PHO003000 PHOTOGRAPHY / Business Aspects. 2. BUS043000 BUSINESS & ECONOMICS / Marketing / General. 3. BUS090040 BUSINESS & ECONOMICS / E-Commerce / Small Business.

Production Credits
Cover design by Designerbility
Interior layout design by Dania Zafar
Book production and editorial services by Grammar Factory Publishing

Grammar Factory's Carbon Neutral Publishing Commitment
From January 1st, 2020 onwards, Grammar Factory Publishing is proud to be neutralising the carbon footprint of all printed copies of its authors' books printed by or ordered directly through Grammar Factory or its affiliated companies through the purchase of Gold Standard-Certified International Offsets.

Disclaimer
The material in this publication is of the nature of general comment only and does not represent professional advice. It is not intended to provide specific guidance for particular circumstances, and it should not be relied on as the basis for any decision to take action or not take action on any matter which it covers. Readers should obtain professional advice where appropriate, before making any such decision. To the maximum extent permitted by law, the author and publisher disclaim all responsibility and liability to any person, arising directly or indirectly from any person taking or not taking action based on the information in this publication.

SHOOT LIKE A NINJA

4 steps to work less, earn more and
superpower your photography business

CHRIS GARBACZ

YUAN WANG

Contents

INTRODUCTION

It was a beautiful, sunny day, the perfect day for a wedding. Chris, a wedding photographer from Melbourne, Australia, and co-author of this book, had just driven an hour and a half to the groom's house and arrived five minutes early, like he usually does. He was eager, excited and raring to go.

He got out of his car, went to the back and opened the boot to grab his gear. Blinking a few times, he shook his head to make sure that he wasn't hallucinating. He paused and took a deep breath. The boot was empty!

In disbelief, he slammed the boot closed, shut his eyes, shook his head, took another deep breath, and slowly opened the boot again. It was indeed empty! *Shiiiiiiiit!*

Chris was literally about to start shooting a wedding and he had accidentally left his camera bag at home. One thought dominated his mind. *I'm a professional photographer who is being paid thousands of dollars to photograph the most important day in this couple's life. How can I have forgotten my bag?*

He couldn't just go home and come back – he would end up being too late for the ceremony. That was not an option. So, he sent a 911 mayday text to his wife, who was at home at the time with two crying children. 'Babe, you won't believe it. I've left my camera bag at home! I need the biggest favour in history. Can you grab my camera bag and chuck it in the car? Grab the kids

and chuck them in the car, too, and drop my bag at the bride's house… it's an hour and a half away,' he begged.

Knowing that he would be reunited with his camera bag at the bride's house, he still had the problem of not having any of his gear at the groom's house.

He took another deep breath, walked up to the front door and knocked.

The groom answered. 'Hey, Chris, how are ya?! Perfect timing, mate, let's rock 'n' roll, everyone's ready for you!'

He decided to tell the groom the truth.

'Jimmy… mate… it's good to see ya. I'm really, really sorry, but I've got bad news. I'm such an idiot. I don't know how to say this, but I left my camera bag at home! Not to worry, I've sorted everything out and it's on its way to Alison's house now. The good news is, I'm here now, I'm ready to rock 'n' roll, and I'm going to photograph you guys… with my phone!'

Long story short, after the initial shock, the groom actually thought it was funny. Keeping his cool, he invited Chris into his house. He wasn't going to let this little hiccup ruin his day.

Apart from the ridiculous embarrassment that Chris felt and the laughs he received from the groomsmen and the family for shooting with his phone, the morning turned out to be a huge success. He lived on to tell the tale.

That's a day that Chris will never forget. As a result, he now has a workflow task that reads: 'GRAB YOUR F'ING CAMERA BAG!' and an internal rule that he cannot turn his car on or leave his house until that task is ticked off his to-do list.

As you'll discover, workflows are important to this book. An effective workflow of tasks, done in order, is key to making every shoot great and every client a super happy and returning one.

But that's only a part of making your photography business thrive.

In *Shoot Like a Ninja*, you'll learn from Chris's fourteen years of experience, as well as from over thirty world-class photographers interviewed specifically for this book – with everything condensed into four simple steps.

So, let's get you shooting and managing your business with the precision, agility and stamina of a Studio Ninja. (Just don't forget your bag!)

PHOTOGRAPHY IN THE POST-COVID WORLD

Despite the lingering effects and uncertainty caused by COVID-19, there has never been a better time to be a professional wedding and portrait photographer.

The barriers to entering the photography market are lower than ever. Gone are the days of prohibitively expensive equipment and post-production software. Rapid advancement in digital technology and increasing affordability due to heated competition between manufacturers means it's easy to own a professional camera and start your own photography business. Bundle that with a laptop, a few choice lenses, a simple lighting kit and some software tools, and you will be ready to take on clients!

Photographers are in demand around the world, in industries including, but not limited to, fashion, advertising, real estate, food, travel, wedding and portrait photography. Driven by couples' higher disposable income, there has also been a huge boom in wedding photography, part of the $300 billion and growing global wedding market.

According to The Knot 2019 Real Weddings Study, the average wedding cost in the US is $33,900. But this varies widely depending on where you live. Couples in major north-eastern cities spend the most – those in Manhattan spend on average $83,000 – while couples in the Midwest spend less, with Columbus's average cost being $23,500. Wedded Wonderland, an online bridal guide, found that the average cost of a wedding in Australia in 2018 was $51,245, of which $3,611 went to the photographer. The boom is good news for wedding vendors, including ceremony and reception venues, DJs, coordinators, caterers, hair and makeup artists and, of course, wedding photographers.

In 2020, the professional photography services industry was crushed by government restrictions on gatherings such as weddings and other events. While decline across the photography industry is predicted in the short term due to COVID-19, there is enormous market potential now that vaccines have become more widely available throughout the world. Events have started to resume and nations are striving to regain normality as soon as possible.

With lower barriers to becoming a professional wedding and portrait photographer, it is more important than ever to stand out among increasingly price-based competition.

Competition is fierce, profit is rare and business is hard for many photographers. The difference between earning an annual revenue of 10K and 150K, while still maintaining work-life balance and your love of the craft, is not determined by how good your photography skills are.

If you want to become a highly paid photographer running a successful business without burning out, feeling like a slave and working unsustainably long hours, then it makes sense to

learn from other photographers who have achieved that goal.

6 PITFALLS THIS BOOK WILL HELP YOU OVERCOME

Having interviewed and talked to thousands of photographers, we've repeatedly come across the same problems and mistakes preventing them from realising their full potential. Some of these may sound familiar…

I'm not making enough money

One of the biggest stress-inducing problems for photographers is a lack of clients and sales. They are not attracting enough clients or simply not generating enough sales consistently across the whole year. They sit and wait, hoping an enquiry will come through the website or the phone will ring.

Even when sales finally pick up, cash flow remains inconsistent and there is hardly any profit. To make things worse, every aspect of the business is dependent on them. If they fall sick or take a holiday, the business stops.

Some photographers are generating enough clients to be really busy, but they are pricing too low to be profitable. It might be easy to get more clients by under-cutting the market and charging less than your competition, but this is an unsustainable strategy. Having a multitude of work but no profit won't lead to long-term success.

You need to be generating enough revenue in order to reinvest in your business; for example, buying props and accessories for your newborn shoots.

Just like running a marathon, generating consistent sales and sustainable revenue from your photography requires focus, planning and lots of practice to perfect. Pricing profitably requires stronger brand recognition, customer loyalty and the ability to close deals, all of which are only possible if you are recognised in your field as the first choice for your clients.

I don't have enough time
When we interviewed portrait photographers, a majority listed 'lack of time' as one of their three biggest problems.

If you have a young family to look after, and possibly a day job to pay the bills, it is easy to see how you would battle to dedicate time to your growing business!

But we all have twenty-four hours in a day. The most successful people in the world don't have more hours than everyone else. They're just better at focusing their precious hours on the things that matter most. They constantly look at ways to improve how those hours can be better spent on the tasks that grow their business most, while delegating those that can be done by someone else.

I'm not good enough
Self-doubt can manifest in many different areas. Perhaps there's a voice inside your head that keeps telling you that you are not good enough to be a successful photographer. Your photography skills are not good enough. You are not good enough to run a business. You are not good enough at sales to make this work. You are not a marketing person.

Many photographers struggle with a lack of skills when it comes to how to run a business, particularly in accounting,

marketing and sales. Those three words seem to make most photographers run in the other direction!

Constantly comparing yourself to the top guns in the industry is another way to erode your self-confidence quickly. If you get bogged down trying to do what everyone else is doing and believing your work doesn't stack up, you don't give yourself the chance to shine.

I don't have a niche

Many photographers try to be everything to everyone. They work across a variety of different genres, not becoming an expert at any of them. Spreading themselves too thin, they don't get known for being a standout in any one field. Not having that identity, they don't become the go-to for anyone.

That's why it's important to specialise. To claim a niche and build a brand that ties together and supports all your marketing efforts and all your products and services. You might start out doing a wide range of things before you learn what you love, but the most successful photographers narrow their focus.

I don't have a system

Often, when photographers struggle, it's not because they are bad at photography. It's because they don't have a system. Instead of spending their time on marketing and hustling for more sales, they are wasting time on mundane tasks like following up leads and chasing up contracts and unpaid invoices.

Lacking a consistent process or workflow, they wing it every time they have a new client or project. This results in 'forgetfulness' – losing track and not emailing back or invoicing a client on time, or even at all.

This can mean an inconsistent experience for different clients. On a good day, you will give some clients an amazing experience, with lovely emails, added value and even gifts. But on a bad day, when you're feeling exhausted or unwell, you will give other clients abrupt communications or simply not try as hard. The quality of your customer service is highly dependent on your mood and availability.

The solution is not just buying software such as studio management, accounting, gallery or album design software. Buying software without changing your thinking will not solve any problems. You have to adopt a systematic approach to your photography business.

I don't have a plan

Unfortunately, many photographers just don't have a plan. They're not marketing, not following up on leads, not upselling products.

They tell themselves, 'I don't know marketing!' or 'I'm not a salesperson!' and constantly distract themselves with low-level tasks. Or they spend time on tasks that they are very inefficient at, such as retouching their photos endlessly, or designing their own albums and canvases when it's not their strength.

When it comes to getting business, they rely on one big marketing idea to do all the work – and only have one sales channel to depend on. All their eggs are in one basket.

In order to excel, you need to have more prospects. And you need to have a plan.

If any of these challenges and gaps sounds familiar, that's why we're here. In the chapters to come, you will learn to approach your photography business with a laser-like focus and a step-by-step strategy.

THE NINJA TRICKS YOU'LL LEARN

In four straightforward steps, we are going to share with you:

- Simple, easy-to-implement marketing strategies that will get new leads flowing into your business and knocking down your door.
- How to easily convert and upsell those leads into paid jobs.
- How to free up tons of time by streamlining and automating as many processes as possible in your business so that you can scale up and get your life back.
- Business tips, automation tricks and real-life examples from highly sought-after, profitable photographers from around the world.

You will learn:

- How to become a highly sought-after photographer whom your clients love recommending.
- Proven and effective strategies that will attract the clients you want.
- Tips on closing those leads that you thought were gone.
- How to simplify your business, eliminate paperwork and free up time.
- A step-by-step plan to turn your passion project into a profitable lifestyle business.

Imagine how incredible it would feel if you had leads constantly coming in, a process to easily convert those leads into paid bookings, and a system that did all those boring, painful, pull-your-hair-out administrative tasks for you – on autopilot... Wouldn't it be life-changing?

WHO IS THIS BOOK FOR?

Before we begin, let's make sure that you're in the right place!

First off, this book is for you if you are a wedding or portrait photographer. And when we talk about portrait photography, this can include family portraits, couples shoots, maternity, babies, pets… there's a wide variety!

We've written this book because, maybe:

- Your photography skills are solid but you need more leads.
- You don't have a marketing plan in place and are hoping the phone will ring.
- You're attracting leads but your price list is holding you back from being profitable.
- You have tried to grow your photography business but finding clients, converting leads, upselling products, chasing payments and just dealing with the whole 'business' side of being a photographer stresses you out.
- You're working long hours, feeling overburdened with the never-ending amount of to-dos.
- You just want to make this whole photography thing work a lot better. You want to get more organised, stop feeling stressed and get your time back. Then you can do more of the things that you love, like shooting more, spending more time with family and friends, or simply having some more time to yourself to chill out and watch the sunset!

This is the business book for you if you hate the word 'business'.

WHO ARE WE?

Now, all of this might sound amazing, but who the hell are we and why are we the right people to be teaching you this stuff?

Chris is an established wedding photographer based in Melbourne, Australia. Despite the stress levels, there's just something about weddings that he loves. There's the creativity, the constant variety, the people, the weather, the uncertainty, the surprises! Photographing a wedding is like mixing every genre of photography all into one extremely high-pressure, ridiculously stressful day, which also turns out to be one of the most important days in a couple's lives. But although it can be crazy, he just loves every part of it.

However, after ten years of juggling an average of sixty jobs per year, Chris became burnt out. While he loved shooting weddings, he was starting to hate the 'business' side of photography.

He was stressing out and spending way too much time on things such as following up leads, chasing up unsigned contracts or overdue payments, and trying to figure out where he was up to with each client and what task he had to do next.

There must be a better way, he thought to himself. He wanted his admin to be as simple and as fun and as automated as possible.

So, frustrated by the amount of time he was spending on administrative tasks, and the time he was spending trialling existing software to no avail, he knew he had to do something: create user-friendly software for photographers that was well-designed, was easy to use and would save them time.

With this big idea in mind, Chris approached his mate, UX (user experience) designer Yuan Wang.

Yuan is a multi-award-winning designer with more than a decade of experience in creating delightful, customer-centric websites and apps. Having completed an Advanced Diploma in Photography, he was running a successful digital agency when he met Chris in the same co-working space. Combining Chris's innate understanding of the photography industry with Yuan's vast experience in user-centred design methodologies, they set out with the mission to develop software that would help photographers automate their businesses and eliminate paperwork.

Fast forward six years, and Studio Ninja has become the world's highest rated studio management software for photographers. It turns out that Studio Ninja wasn't just needed to solve Chris's problems; it has been busy solving the same problems for thousands of photographers around the world in seventy-two countries.

These photographers include Erika Mann (International Wedding Photographer of the Year), Dan O'Day (AIPP Wedding Photographer of the Year) and Scott Johnson (FBIPP, FSWPP, MCGWP, Master of SWPP), as well as many of the current and past Rangefinder's 30 Rising Stars.

The constant need to build features for Studio Ninja that help photographers solve business problems has given us unique insights into their everyday struggle.

We believe there is a better way. So, we have combined our own learnings with insights from the world's top photographers into four simple steps that will show you how to attract more of the work you prize, earn more profit and spend more hours doing what you love without being chained to your business.

Photographers who 'shoot like a ninja' do not struggle. They

are respected in the industry. They attract their ideal clients consistently. They're highly paid and can afford to do the fun stuff. Now it's your turn.

CRAFT YOUR NICHE

*Chase the vision, not the money; the
money will end up following you.*
Tony Hsieh
CEO of the online shoe and clothing company Zappos.com

One of the biggest mistakes that photographers make is not having a niche.

Having a niche makes it easier for you to sell to your ideal client, increases the price at which your ideal client is willing to pay for your services, and reduces your cost of business by simplifying your operation and making it more efficient.

Having a niche also allows you to make your pitch more targeted, which will make every other piece of marketing collateral you ever create – such as your website, portfolio, brochures, social media posts, and so on – far more relevant and compelling for your prospective client.

Let's say you were at the gym and, in a freak accident, you broke your knee and needed urgent treatment. Would you want to see your generalist family doctor or the specialist surgeon who operates on knee injuries every day? Do you think it would cost more to see the specialist surgeon? The answer is most

likely yes, but you will be willing to pay more to get your knee properly treated.

 Andrew Hellmich on the mistake photographers make:

They go looking for different genres. They might be a portrait photographer but they see a headshot photographer making this amazing money. 'Oh, maybe I should do head shots too.' Then they see a pet photographer. 'Maybe I should shoot pets as well. That's a good market.' Next thing they've got this business that's doing four or five different things, nothing really well, and all over the place, and then they've got no time. So, it comes full circle.

I think spreading yourself too thin, doing too many genres – you sort of have to do that in the very beginning because you really don't know where you want to go unless you do a bit of it; most people don't. That's when you find your way and you lose things, chop things away as you get better at one thing. The most successful photographers that I interview and that I know tend to specialise in one or two things, rather than going too wide and too thin.

Here's the thing: Niche is where you start, not where you end. You can start small and narrow, experiment and find success, and perhaps expand later. Starting with a niche allows you to test and experiment whether this is the right area to be focusing on to attract your ideal client, then you can consider offering services outside the niche if that fits with your plans.

You might be wondering how this fits in with getting recurring work from the same clients. Surely you shouldn't turn down different work if it's offered to you, just because you've proven yourself in the niche job you've already done?!

A perfect example is the maternity/newborn photographer. It makes perfect sense for that photographer to photograph a newborn up until the age of one or two, for example, because that all fits in together and that's a great way to get a client returning. Up to a point, yes, you do want to make more money from one single client.

However, do you follow that baby through till they grow up and you photograph their graduation? Do you photograph their wedding? Do you even shoot the first birthday party? Imagine the dad's got an air-conditioning business. Do you go and do his headshots? That doesn't really make sense.

Sometimes it's difficult to say no. But you save time by not putting yourself through all the drama of creating a price list and attracting more of that work that isn't your focus. And you can then put that time and effort into your existing business and core product – your maternity/newborn shoots – and make those much better rather than spreading yourself too thin.

Photographers are confused about niching, because there are two opposing streams of thought. There are nuances. And a line between niching and over-niching. It's true that some people niche themselves out of the market. They are so niche that they only shoot this one thing, and they don't have enough customers in that niche to sustain the lifestyle that they want.

If a photographer has a client who already loves their maternity and newborn portraits, the photographer may feel that they should be shooting everything for them, like their family portraits,

because it's easier to go back to the same client for business rather than acquiring new ones. However, there's a line where it screws up the photographer's business model, because it's not efficient for the photographer to also shoot the child's first birthday party as an event photographer. There is a difference between going back to the same customer for more jobs and shooting everything that's possible with this client.

The danger is that some photographers can niche themselves so far that they lose the ability to attract enough clients. This has to do with the population surrounding you that you're servicing. So, if you live in a small town, say Echuca in northern Victoria, Australia, then it won't make sense if you're photographing newborns and there's only going to be one baby born every week. You're not going to survive. You have to broaden your skills. Maybe you have to learn how to do headshots. Maybe you have to learn how to do some product shots. You have to look at your business and see if it's going to be viable. In this scenario, your niche becomes more location-based due to your market size, so you're better off niching as the local Echuca photographer, rather than the newborn photographer.

If you have a good, serviceable population and there are enough people to support your niche, you'll be far more successful if you niche. If you're a wedding photographer, it still makes sense to shoot portraits. Those two things can go together. But if you're a wedding, a portrait, a pet and a brand photographer, you're spreading yourself too thin.

Lisa Devlin on having a niche:
The South of England is very, very saturated. It is an incredibly difficult thing to stand out. I think that in

a very busy market you cannot go too niche because the mainstream is covered, you know? It's very easy to find a mainstream, traditional photographer. So, what can be a good strategy is to be really niche. As niche as possible. Because whatever that is that you are passionate about, and that you can put across, there are other people who will connect with that.

If you try to be all things to all people, you end up being nothing to anyone. People keep saying to me, 'Oh, you get such cool clients.' As if that's an accident, as if that just happens. When it's, 'No, actually, I work incredibly hard to attract a very specific type of client.'

FIND YOUR NICHE

So, how do you find your niche and build a portfolio that sets you apart?

In order not to be a jack-of-all-trades, you need to specialise. Think about specialising within a specialisation – if you are a wedding photographer, for example, are you a destination wedding photographer? An aerial elopement photographer? A luxury venue photographer? Or more of an unorthodox wedding photographer?

 Joel Alston on his niche:

I have a Toyota Hiace that I've decked out myself into a campervan. When I do a lot of my Australia-wide weddings, I take the campervan and just sleep in the van and cook all my food. Pretty much just live in my van for a week or however long I'm away for.

It's actually quite fun because, in the back, I've got two bench seats. I'll pile the whole bridal party, with the bride and groom, into the campervan, and we'll go driving around on the property for bridal party shots with heaps of beers. It's definitely not legal! It's called the Gus Bus. The Gus Bus is an extension of my identity.

My tagline is 'fuck traditions, do it your way'. I pretty much call out all the wedding traditions and just do everything anti-wedding, really. I never used to be artistic or anything. I was a sporty kid. I love adventuring and travelling, and incorporate that into my work.

What made me unique, when I first started, was my branding, Barefoot & Bearded, which bred this culture and this identity of free-flowing, relaxing, unintimidating photography, which became adventure really quickly.

Figuring out your identity can be either the easiest thing in the world or come with its own set of challenges.

As we discussed in the introduction, one of the issues photographers face can be an element of impostor syndrome. You think you shouldn't be in the arena and tell yourself you're not good enough. You compare yourself to everyone else and what they are doing, and you perceive yourself as lacking. This can hold you back from doing what you enjoy and actually enjoying it. And it can hold you back from finding your niche.

Kristen Cook on 'comparisonitis':
I used to be on a lot of online photography forums and groups, and everyone was always sharing their

opinion about the ways to do things. Newly submitted photos would end up being torn to shreds by other photographers. In the early days, I really sought their feedback and criticism because I thought that was what would help me grow as a photographer.

Every morning I would open up my feed, cycle through all of the photographers that I follow. I would look at all of their images and just think, 'Ugh, I can't do this.' It was so soul destroying because I was constantly comparing myself against all of my peers and all of these people that I admired. What I then realised was that my work was just looking the same as everyone else's.

Eventually I made a decision and stopped following all of them unless I personally knew them. That for me was the biggest turning point because it meant I was no longer paying attention to what everyone else was doing around me and I could just get on with doing my own thing. It meant that I could take a step back and go, 'What do I really connect with? What do I really love about my work? What do I really love shooting? What do I find in my photography that I really connect with?'

When I did that, I disconnected from my competition and started to stand out from everyone else because I wasn't shooting what others were shooting. I didn't know what they were shooting! The benefit of that is that I could then just shoot what I wanted to shoot and didn't have to necessarily stick to the trends that everyone else was going with. That's been one of the main catalysts for my business growth.

You have to decide what *your* story is – and what makes your style and story unique. This knowledge feeds into your brand, and truly focusing on what you want to do makes it possible for you to envision your ideal customer. Whom your ideal customer is affects not just how you approach your marketing efforts, but also where you channel them (more on having a marketing plan in the next step!). And once you know exactly whom you're speaking to, you can decide what products you want to offer them and work on positioning yourself within your market – building up recognition through awards and testimonials relevant to your niche.

First, let's look at your story.

What's your story?

Your story is personal and that's why it's meaningful. Telling your story is a way to connect with the people who will appreciate you for who you are and who will, therefore, want or recommend your services.

You may be someone who hates shooting in the city but loves shooting in the country. Or you may be someone with a deep connection to where you live. Perhaps you've grown up there and intend to spend your whole life there – you love the landscape, you know the locals, you prefer to operate there and can make it an experience for your clients because you're born and bred. If they're after a certain kind of vendor or venue in the area, you know exactly whom or where to suggest. You can tell them the history of the region, the stories that make certain places special, and what makes other places the perfect spot for a photoshoot. Your brand involves being an authentic guide – living and sharing your passion for your home.

Your history, your personality, who you are – these are what

make you a powerful brand to connect with. These are the basis of your unique selling point (USP).

Tim Williams on your USP:

Look, for a long time, I tried to distinguish my USP. And at the end of the day, it's me. There's no other me out there. I was really focused on building a style that was so unique that no one else was going to shoot like me. But being a photographer is such a saturated market, especially in the digital world we live in; we have photography so readily accessible. Once I was able to put aside focusing on creating a style and the technicalities of it, I was actually just able to be myself and provide a service where people enjoyed being around me at weddings and had a good time. I focused on providing a great service, and everything flowed from there.

Your brand as a photographer is an extension of your personal brand, and people's connection with your brand can be enhanced through storytelling. It's through telling your story that people can come to understand your values and beliefs. If theirs align with yours, you've made the connection that becomes the foundation of a relationship, whether that's a partnership with a vendor or a contract with a customer.

Ben Sowry on how your personal story can become your brand:

I had a pretty crazy start to my career; it's definitely been a bit of a rough road here. When I was a kid, I lost both of my sisters to late infantile Batten's disease,

which is an extremely rare inherited terminal illness in children. Tegan was my older sister, and we lost her in 1994, and Chevon was my little sister, whom we lost in 2002. They were among my very best friends and to lose them crushed my world in the most formative years of my life. Battens disease is super aggressive and it affects the motor skills and your ability to walk, talk, sit and handle items. You're eventually wheelchair bound with recurring seizures, blindness and eventual death. They were both seven when they passed away, and my parents photographed every moment with them, in their lives, and everything was just done candidly.

Those photographs are something that I hold on to extremely dearly, and that gave me the realisation that I had the ability to give the gift of preservation, like my parents had given to me. When I was seventeen, I followed in the footsteps of my grandfather and became an electrician, something so far from where I am now. And I pretty much photographed everything. Family events, annual Christmas parties, my grandparents' sixtieth wedding anniversary. And there wasn't necessarily any structure to what I was doing, but I just knew that these moments were important to me. And a few years later, I lost my grandmother to a stroke and that devastated me because my grandparents were like my second parents.

A year before we lost my pop, I went to his house for a regular Friday afternoon visit, but I took my camera, and I meaningfully talked with him around his home. And those photographs mean the world to us because that's the house that he built with his own two hands,

and he was so damn proud of it. My screensaver on my phone's still one of the portraits that I took of him, and I haven't changed it since we lost him because it just means so much to me to know that he's with me wherever I go, and I can just glance at something and revisit him.

Now I only have my mum and my dad left and my wife, Georgia, and I feel so exceptionally lucky to have these incredible people in my life. And they've supported me through my transitions in career, and given me the approval and the guidance I needed to get me through.

Losing the majority of my family before the age of twenty-nine has really changed my perspective on what it means to document the world around us. I know firsthand that, chances are, we'll outlive most of our family, and everyone will go through the same pain that I've experienced.

I keep that in the back of my mind when I'm photographing a wedding, that the community that surround my couple are just as important as the couple themselves. And I really long to document the inter-actions between loved ones. It's the little things, like the reassurance of the mother's hand as it brushes her daughter's back on the morning of the wedding, or a grandmother pulling out a tissue and licking it and wiping away crap off the young child's face, because there are things that happened to me, and there are things that I want to remember, and I know that means a lot to my clients. I just want to make sure that I give

them that little gift. So, when the occasion arises, where they do lose them later on in life, they have something to carry with them. And it's a moment that they and their families can look back on, finding comfort in revisiting those moments.

Did you get a sense of Ben's values and beliefs from his story? Consider the key concepts that jump out at you: family, compassion, community, remembrance, love, comfort... These, or a variation on these themes, could be considered Ben's core values. What are yours?

Exercise: Values and beliefs

Take a piece of paper and a pen – you might want to use a fresh notebook and return to it for future exercises in this book – and have a quick brainstorm.

Ask yourself the following questions and make some notes. Do this in whatever way comes naturally – whether bullet points, a mind map, full or fragmented sentences, or just words and phrases. If you're more visual, draw doodles that represent your answers, and/or use different colours to highlight different questions/themes. Feel free to use any of our examples if they hit the nail on the nose, or have a think outside the box and see what comes to you.

- *What qualities do you most admire?*

Come up with ten if you can. E.g. courage, honesty, risk-taking, caution, going against the current, sticking to the plan, being humble, standing out, taking the road less travelled, authenticity, being adventurous, kindness, empathy, joie de vivre,

rebelliousness, attention to detail, blue-sky thinking, taking things slow, failing fast...

- How would you describe yourself?

One way to go deeper when you're asking yourself questions is the '5 Whys' approach. This was invented by Sakichi Toyoda, the founder of Toyota, back in the 1930s.

Here's an example: You might describe yourself as hardworking. Why? Because you put the hours in and do the job till it's done. Why? Because you want to do a good job. Why? Because you care about the result. Why? Because you want people to be delighted and 'wowed' by your work. Why? Because happiness comes from reliving those moments through your photography and that's what drives you.

- How would others describe you to your face? If you get stuck, try the 5 Whys.
- How would others describe you if you weren't in the room?! Does this marry up with how you want to be perceived – and with how you perceive yourself?
- What matters most to you in life? Definitely consider the 5 Whys here.
- On your death bed, with one last breath to impart one final piece of wisdom to your loved ones about how they should live their lives, what would you say?

Circle words in your answers that jump out at you and key concepts that are important to you. Can you distil this down to three to five key words or phrases that represent your core values?

Think about your story – does it communicate these values?

Brand archetypes

Jeff Bezos, founder and CEO of Amazon, said it best: 'Your brand is what other people say about you when you're not in the room.'

Photographers have personalities so, similarly, their personal brands also have personalities. If you want to build a great business and attract your ideal client, you need to be skillful at matching your market with your brand.

Brand archetypes embody the universal stories and journeys that all human beings share. They evoke our imagination, dreams and aspirations, and mirror our fears and intentions. They are universally shared symbols that connect the conscious mind with subconscious meanings, concepts, moods and desires.

Many brands that we know well can be associated with one of twelve fundamental brand archetypes. Here are the twelve basic identities, or archetypes, a brand can assume:

1. The HERO overcomes all odds

The Hero archetype wants to triumph over adversity and evil. Hero brands are admired for their strength, stamina and courage. They have the ability to challenge themselves, inspire others and achieve the impossible, even if that means sacrificing for the greater good.

A Hero brand, like Nike, challenges people to push harder than they think is possible, and to achieve greater heights, by promoting phrases like 'never stop winning', 'dream further' and 'Greatness is not born, it is made'.

2. The MAGICIAN makes dreams come true

Magician brands know how to dream BIG and turn the wildest ideas into reality. With the ability to view the world through many

HERO

Self-sacrifice | Courage
Redemption

Wonder Woman
Nike · Harry Potter

MAGICIAN

Intuition | Cleverness
Charisma

Disney · Dyson
Steven Spielberg

CREATOR

Creativity | Imagination
Self-expression

Lego · Apple · Adobe

SAGE

Wisdom | Intelligence
Truth-seeking

Harvard University
BBC · Oprah Winfrey

RULER

Power | Confidence
Leadership

Mercedes-Benz
Rolex · Beyoncé

INNOCENT

Purity | Trust
Wholesomeness

Dove · Nintendo
Forrest Gump

12 BRAND
ARCHETYPES

Which brand
archetype are you?

EXPLORER

Independence
Bravery | Freedom

Jeep · Indiana Jones
National Geographic Society

LOVER

Faithfulness
Vitality | Appreciation

Chanel · Häagen-Dazs
Godiva Chocolate

CITIZEN

Respect | Fairness
Accountability

Budweiser
Ikea · Target

CAREGIVER

Compassion
Patience | Empathy

Salvation Army · Patch Adams
Johnson & Johnson

JESTER

Humour | Originality
Irreverence

m&m's · The Onion
SpongeBob SquarePants

REBEL

Risk-taking | Provocation
Brutal honesty

Harley-Davidson · Gordon
Ramsay · Richard Branson

different perspectives, this archetype is charismatic, clever and awe-inspiring.

Disney is an example of a Magician brand, offering a transformative experience for audiences around the world. Dyson, another Magician brand, doesn't just make better vacuum cleaners, it completely revolutionised appliances, including vacuum cleaners, air purifiers and hair dryers, by using ground-breaking, innovative technology.

3. The CREATOR wants to create something new

Supreme creativity and imagination are key characteristics of the Creator archetype. They are determined in their pursuit of perfection and like to think outside the box. They are often associated with artists, writers and entrepreneurs, all of whom have strong desires to express themselves.

Many Creator brands live in the field of art, design, technology and marketing. Examples of Creator brands, such as Lego and Apple, strive to create products that people cannot live without. Apple products and their marketing campaigns are like pieces of art, with a highly developed sense of aesthetics, and they attract people who see themselves as creative and having good taste.

4. The SAGE looks for the truth

For Sage brands, wisdom and rational decision-making are the keys to success. Everything else is secondary to the pursuit of knowledge. This archetype is highly independent and pragmatic, always looking to learn and remain objective.

A Sage brand, like Harvard University, commands respect by illustrating brilliance. Another Sage brand, Oprah Winfrey,

is sought after by millions of people around the world for her guidance, mentorship and ability to enlighten with information and knowledge.

5. The INNOCENT just wants to be happy

Everything is pure, virtuous and content in an Innocent brand's world. An Innocent brand will never guilt you or try to convince you excessively. This archetype is honest, trusting and wholesome. They are forever optimistic, which means the glass is always half full.

An Innocent brand, such as Dove, embodies the purity and simplicity associated with a dove. Dove is positive and reaffirming in their advertising, wanting women to feel confident and happy about themselves. Forrest Gump is another example of an Innocent brand. He is a child in an adult's world, retaining his love for life and boundless optimism for the future.

6. The LOVER is devoted to you

Passion, pleasure and sensuality are keys to the Lover brand's heart. A Lover brand wants to evoke emotions, such as memories of the most intimate moments in your life. This archetype loves beauty and closeness. It embraces all types of love, including parental, friendship, familial, spiritual and romantic.

What do you buy to celebrate or treat yourself? How do you indulge your significant other? Chances are, you're buying from a Lover brand. Think of high-end luxury brands, like Chanel or Christian Dior. However, Lover brands are not always high-end and expensive. They can also be found in the supermarket, like Godiva Chocolate and Moccona Coffee.

7. The REBEL seeks revolution

Rebel brands are brave, provocative risk-takers. They are not afraid to break rules and challenge traditions. They are a force to be reckoned with. The Rebel archetype appeals to the part of you that skips classes in high school to attend a rally for climate change.

Celebrity chef Gordon Ramsay embodies the take-no-prisoners attitude of a Rebel brand. Known for being foul-mouthed and uncompromising, he brings fresh perspectives to young chefs and restaurant owners and gives them the wake-up call they need to change their lives.

8. The JESTER lives in the moment

Humour, silliness and surprises are all in a Jester brand's toolkit. Jester brands want to make you smile with light-hearted fun. They are wickedly creative, mischievous and irreverent. This archetype sees life as a playground of opportunities.

The perfect example of a successful Jester brand is m&m's, known for entertaining audiences with ads featuring their candy characters, who are often caught in humorous situations. Another Jester brand is the American satirical news website The Onion. They take current issues and present them through a ridiculous perspective to make you laugh and feel disturbed at the same time.

9. The CAREGIVER nurtures and cares for you

Caregiver brands simply want to be there for you. They are devoted to supporting others, and providing reassurance, advice and an open heart. This archetype is compassionate, empathetic, generous and self-sacrificing.

The Caregiver archetype is a natural fit for many not-for-profit organisations and charities, such as the Salvation Army. Another Caregiver brand would be Johnson & Johnson, one of the world's largest healthcare companies, whose messaging is about caring for the world.

10. The CITIZEN seeks to belong and fit in

This archetype is driven by a desire to be fair and to treat everyone with respect. Citizen brands are seen as hardworking and community-minded. They believe in the power of the collective above profit or individual gain. They see the good in everyone.

Examples of Citizen brands include alcoholic beverages such as Budweiser or Victoria Bitter. They are unpretentious to enjoy and have the ability to bring people from all walks of life together for a good time. Citizen brands find joy in the everyday.

11. The EXPLORER wants to break free

With freedom as their top priority, Explorer brands crave new experiences and independence. This archetype likes to push boundaries, enjoys unexpected discoveries, and will take great risks so as not to be trapped in boredom.

An ideal Explorer brand is the National Geographic Society, part-owner of the National Geographic channel, and one of the largest not-for-profit organisations in the world. It is committed to exploring and protecting the planet, and encourages its young audiences to activate their 'inner explorer'.

12. The RULER is born to lead

Dominant and confident, this archetype sees itself as a role model for others to follow. Ruler brands seek power and control,

command people's attention, and provide them with security and stability. They have a proven track record and like maintaining rules that they have created.

Examples of the Ruler archetype include many luxury brands such as Rolex, Mercedes Benz and Hugo Boss. They are unapologetic about their status as market leaders, and appeal to people's desire to be important, influential and successful.

Photographers and their archetypes

Here are some examples of how photographers from around the world have established their brand archetypes through their work and the way they communicate about their photography.

PHOTOGRAPHER	Sam Docker
WEBSITE	https://samdocker.co/
TAGLINE	Authentic and genuine moments, creatively captured.
PHOTOGRAPHY STYLE	Artistic, emotive. Unexpected, delightful moments.
ARCHETYPE	Creator
ATTRIBUTES	Creativity Invention Unique point of view
APPROACH IN THEIR OWN WORDS	*I'm constantly creating. From the second I step out of my car on the morning of a wedding, right through to the moment I get back in at the end of the night, I don't stop making creative decisions. I don't stop watching, observing, moving or documenting, and I always just go with the flow of the day, there's very little in the way of a plan or shot-list. Instead, I follow my gut.*

PHOTOGRAPHER	Alex Cearns (Houndstooth Studio)
WEBSITE	https://www.houndstoothstudio.com.au/
TAGLINE	The strongest bonds we create are those with our animal friends.
PHOTOGRAPHY STYLE	Intimate, humorous, will tug on your heartstrings.
ARCHETYPE	Lover
ATTRIBUTES	Affection Faithfulness Unity
APPROACH IN THEIR OWN WORDS	*We love your pets like our own. At Houndstooth Studio we see your pet as you see them. That inquisitive head tilt. The lolloping gait. Their exuberant, rough and tumble play. Their eternally loyal and loving smile. We see all of these nuances – they're hallmarks of your pet's individual personality – and we capture them in timeless portraits of exquisite detail and full colour.*

PHOTOGRAPHER	Erika and Lanny Mann (Two Mann Studios)
WEBSITE	https://twomann.com/
TAGLINE	Transcend wedding photography.
PHOTOGRAPHY STYLE	Transported to another world. Romance set in magnificent landscapes.
ARCHETYPE	Explorer
ATTRIBUTES	Originality Craving new experiences Avoiding boredom
APPROACH IN THEIR OWN WORDS	*Our adventures in wedding photography began on a mountain summit during our very first date. That's when we discovered our mutual passion for adventure and each other. Our goal is bold and simple; we want to tell your wedding story through compelling images that transcend wedding photography. We believe that wedding photography doesn't have to be safe and boring.*

PHOTOGRAPHER	Kristen Cook
WEBSITE	https://www.kristencook.com.au/
TAGLINE	Love chaser. Light painter. Storyteller.
PHOTOGRAPHY STYLE	Monochrome or muted colours, timeless, tender.
ARCHETYPE	Innocent
ATTRIBUTES	Purity Sense of wonder Unconditional love
APPROACH IN THEIR OWN WORDS	*Newborns are infinitely giving and authentic. They are soulful, vulnerable, honest and pure – my aim during sessions is to connect with those qualities in each and every newborn baby I have the pleasure to photograph. My style of newborn photography is that I am totally baby-led during my sessions. Your newborn is my ultimate guide, with a strong focus on love, light and texture.*

PHOTOGRAPHER	Joel Alston (Barefoot and Bearded)
WEBSITE	https://barefootandbearded.com/
TAGLINE	Fuck tradition!
PHOTOGRAPHY STYLE	Unconventional, moody, finding beauty in the ordinary.
ARCHETYPE	Rebel
ATTRIBUTES	Risk-taking Provocative thought Brutal honesty
APPROACH IN THEIR OWN WORDS	*Wedding is a dirty word that society uses to create a preconceived process of how to marry your spouse.* *This forces couples to spend thousands of dollars to create a spectacle to impress their family and friends without deep, conscious consideration on what they actually want to do to celebrate their relationship. We must start educating society on more alternatives for how to get married!*

Exercise: Your archetype

..

Take a look around these photographers' websites. Having seen how these guys own their archetype, pull out some paper or your notebook and have a think about how you would fill out the fields for yourself.

- *What's your tagline?*
- *What's your style?*
- *Does this resonate with a particular archetype and its attributes?*
- *How would you describe your approach?*

It's easy to tell what sort of customers the branding of each different photographer above is targeted at – and how and why it will attract some people over others. This step is one of the most important in business – considering whom you're talking to.

WHO IS YOUR IDEAL CUSTOMER?

As Sam Walton, founder of Walmart, said, 'There is only one boss. The customer. And he can fire everybody in the company from the chairman on down, simply by spending his money somewhere else.'

Seriously, when it comes to your target customer, if you can't summarise them into one single person, then you don't really understand them. You need to know exactly whom you're talking to. You need to be able to picture them! You need to know where they come from, where they work, what they like and why, where they hang out and whom they trust.

Create a customer persona

A persona is a powerful way to think about your ideal client. Think of a persona as the perfect customer prospect.

Personas are semi-fictional characters that have been created from customer research. They're meant to help you figure out the natural types of behaviour that someone – your client – would demonstrate in a particular scenario.

So, why should creating a customer persona be important to you?

- Coming up with a persona for your customer enables you to understand and predict the needs and desires of your target market.
- It enables you to communicate a customer's characteristics in a compact and easily understood way.
- It puts a face on the person for whom you are designing your products and services.
- It gives focus to projects by building a common understanding of customers across teams – for example, you could offer your customer persona to your website designer. From it, your designer can understand the kind of experience you want to provide to your customer when they engage with the different aspects of your website.
- A persona can help you and others empathise with your customers, given your understanding of their behaviours, goals and expectations.
- It's a reference tool that can be used in your business, helping with activities ranging from creating a marketing strategy through to implementing a Facebook campaign.

Okay, now let's look at a couple of examples of a customer persona.

WEDDING PHOTOGRAPHY CLIENT PERSONA	
NAME	Bree
AGE	28
GENDER	Female
OCCUPATION	Marketing manager
LOCATION	Sydney, Australia
HOUSEHOLD SIZE	In a long-term relationship and about to get married
EDUCATION LEVEL	University educated
INCOME LEVEL	High income earner, 90K+
CURRENT SITUATION/PERCEPTION	
NEEDS	Wants to find a photographer that fits her budget. Wants wedding photos that show off her personality – adventurous, outgoing and fun. Wants to make sure all the important moments are beautifully captured.
PAINS	Doesn't want to look 'fake' – wants the photos to capture the relationship in an authentic way. Concerned about not looking good enough.

FAMILY PORTRAIT CLIENT PERSONA	
NAME	Sally
AGE	36
GENDER	Female
OCCUPATION	Receptionist
LOCATION	Melbourne, Australia
HOUSEHOLD SIZE	Married with two children. Her husband works full time.
EDUCATION LEVEL	Diploma level
INCOME LEVEL	Median household income, 100K+
CURRENT SITUATION/PERCEPTION	
NEEDS	Wants new artwork for the walls of a new house that the family has just moved into.
	Wants to find a photographer that will capture her family members' love for each other beautifully.
	Wants a photography who has flexible working hours to work around the children's schedule.
PAINS	Too busy to find time for a photography shoot.
	Concerned about not looking good enough.
	Concerned that her children won't behave during the shoot.

Exercise: Your customer persona

...

Sit down, pull out some paper or your notebook and brainstorm a list of characteristics for your ideal customer. Use the example above as a reference.

Think of their:

- *Name*
- *Age*
- *Gender*
- *Occupation*
- *Location*
- *Household size*
- *Education level*
- *Income level*
- *Current situation/perception*

Now let's dig a little deeper. The reason we're doing all this work is so we know how we can find our ideal customer – and, more importantly, how we can put ourselves out there so that they can find us.

Let's really explore the preferences of this persona. Start by writing down what you already know about your ideal client. Then ask yourself:

- *What people or organisations already have your ideal customers as clients or users?*
- *What kinds of entertainment do they consume?*
- *Where do they get their news?*
- *Where do they find services?*
- *Where do they watch videos and what do they like to watch?*

- *What do they like to listen to? Music or talk radio? What podcasts do they listen to?*
- *What magazines do they subscribe to?*
- *What types of books do they like to read?*
- *What blogs and/or newsletters do they subscribe to?*
- *What are their hobbies?*
- *What clubs do they belong to?*
- *What associations or groups are they members of?*

If you can't answer the above questions easily, you will need to conduct more research, which can be as simple as looking things up online or setting up a few interviews with your existing clients. An easy way of setting up an interview is to take a customer out to lunch or for a coffee. Here's an example of an email that you can send:

Hi Sally,
I had so much fun working with you, I was wondering if I could pick your brain about a few things that could improve my services. Are you available for a coffee and if so, when is a good time?
Cheers,
Chris

Once you have written down answers for the questions above, make a list of five to ten channels, websites or platforms where your ideal client can be reached.

For each channel, determine the destination where your client will most likely make an enquiry, and also identify the content that you will need to create in order to engage your client.

Here's an example:

CHANNEL	DESTINATION (point of enquiry)	CONTENT REQUIRED
Referrals	Website/Facebook/ Instagram	Timely response to incoming messages/email.
Google Organic Search	Website	Landing page which is ranking well for 'wedding photographer Byron Bay' or 'family portrait photographer Byron Bay' or 'pet photographer Byron Bay' etc.
Google AdWords	Website	Search ad and landing page
Facebook	Facebook business page	Facebook ad and video
Instagram	Instagram profile/ Website	Instagram posts or reels
3rd Party Blogs	Website	Guest blog articles, e.g. 'Top 5 mistakes to avoid when hiring a wedding photographer'

Now you've thought deeply not just about whom you're talking to, but also where you're going to engage with them and where they will end up, we can come up with exactly what you're going to say to them through different mediums via these different channels. This forms part of your marketing plan, which we'll turn to in the next chapter.

But wait, before we head there, the next thing to think about when niching is the product that you offer.

YOUR PRODUCT NICHE

Having a product niche is about having special products that other photographers don't have. Perhaps this comes down to choosing a specific supplier for a certain aspect of a product, such as albums, packaging, framing or printing. One example might be integrating dried/pressed flowers from the bridal bouquets and buttonholes into a couple's album or frame. Or perhaps it's about creating a special experience that people can't get elsewhere.

Think back to the perspective of our 'Barefoot & Bearded' photographer, Joel, tootling his bridal party around in the Gus Bus. And take a look at Verve (www.verveportraits.com.au). Verve exploded onto the family portrait scene in Australia with a unique take on the 'experience' of taking family portraits. Previously, people perceived the taking of a family photo in a studio as an experience that was quite staged, formal and potentially painful to sit through. Verve's approach is wildly different, encouraging families to engage in physical activities, such as jumping, running, pushing and pulling, and so on. This creates a special experience in which the family genuinely has fun in the studio, resulting in truly emotive images where they can be seen laughing, crying and bonding with one another.

Exercise: Your products

Grab your pen and have a think. What are your current products or product ideas? List them out.

Are you already operating in a niche, even a super niche? What kinds of ideas can you come up with that would work well

for that niche? Say you're a destination wedding photographer who specialises in heli-weddings in mountain and lake locations or in water-access-weddings on remote beaches. Is there something tied to or from the unique spots you visit that can be incorporated into your product somehow, perhaps in the design or the delivery? Or is there something you could incorporate into your service when you're at the location that would make it truly unique? Perhaps you're a family portrait photographer who prefers to visit families in their own homes to capture the most authentic interpretation of their lives. Could family keepsakes or an important element from the family home be tied into your product or service somehow?

Think about whether this is something you can incorporate alone or whether you'd need help from a supplier. Either way, what are the associated costs? Do these weigh up against the benefits of having this niche product? Come up with more than one idea and perform a cost-benefit analysis for each one.

Nothing is set in stone – experiment! Some ideas may not make it off the page and that's fine. Others may evolve into something else entirely once you start doing the research. Perhaps a supplier you speak to suggests a tweak that results in something extraordinary – or you discover from them that the idea just can't be done. Remember, you can always go back to the drawing board. Some ideas may not grab your ideal customer; others might give you wings.

All right! Now you have something special to offer the people you're talking to – as well as knowing exactly where to find them to let them know about it. The next thing we'll turn to in this chapter is positioning yourself in the market you've chosen. You

want to take ownership of your niche and become the GO-TO photographer for your ideal customer. The best thing you can do once you're operating in your niche is build recognition there, giving potential customers every reason to come to you.

BUILD RECOGNITION

Time to shine! There are a variety of ways you can earn your stripes in your arena and build recognition in your target market. These can start with something as simple as gaining standout testimonials from clients for your website, or reviews posted on a public forum like your Facebook page or Google. They can range up to winning accolades and awards from established institutions and industry bodies.

Here are a few methods to consider:

- Compete for awards – There are a wide range up for grabs, whether within an association or society you belong to, or with a local or international photography body or group. Think outside the box – you don't necessarily have to compete with a scary selection of your peers for a prestigious photographer of the year award from WPPI or the Sony World Photography Awards, for example, though that may be just up your alley. There are also community business awards that are multi-disciplinary and may grant exposure to a certain cross-section of society that could line up with your niche. Remember that you can't win anything if you don't take part, but don't forget that not everything is either win or lose – there are also opportunities to achieve membership levels or accolades based

on time and commitment to certain societies rather than on the basis of presenting one isolated piece of work for judgement against others.

- Get published – Again, there's a variety of options in this arena. You may want to aim for magazines, websites or blogs. You may be looking at international readership or readership in a select suburb. These don't have to be photographer-specific publications. You could team up with a vendor, like the venue where you like to take families for their family portraits, and your published work could be advertising images they've chosen because of the quality.

- Run workshops – Teaching can be the perfect way to build credibility in your field. Educating others in your expertise and sharing the tips that make your life run smoothly offers untold value. It needn't mean revealing how to replicate your style or giving away the elements that set you apart from the competition as a photographer. There may be something you're incredible at and it may only be loosely related to taking your images, but it's something valuable you offer, which makes you an authority on the subject. Perhaps you have tips on how to shoot better, how to do marketing better, how to improve your photography business processes. Perhaps you know all about how to manage going from the nine to five to embracing life as a freelance business owner. Becoming an expert that others refer to and look up to sets you apart with your customers.

- Speak at events and conferences – This again sets you up as an authority in your field, whether you're talking

about a specific technical aspect of photography, implementing a new technology in your business, or excelling in attracting customers in a particular market. If you have an inspirational story, what opportunities are out there for you to share? There might be a chance to shine at a wedding expo or an RSPCA charity fundraiser, a school prizegiving or the local actors' guild Christmas bash.

- Become a recommended supplier – Don't underestimate the credibility you can gain from being the photographer of choice when it comes to different vendors. Perhaps you're the town vet's pick for pet portraits or the local medical centre's suggestion for a maternity/newborn photographer. Build relationships and improve your standing in your niche.

Take a moment and think about what appeals to you. What action could you take to begin raising your profile?

 ### Lanny and Erika (Two Mann) on winning awards:

Winning awards seems like a pretty high achievement, an accolade if you will. Upon reflection, it has changed our work massively – but maybe not for the reasons you would be expecting. In 2014 and 2015, Erika and I were each named Fearless Photographer of the year, which, of course, was like a big accomplishment, right? And it ended up being a bit of a turning point for us, in our career and our work. It was a bit of an existential-type reflective moment in our career, where it's like, okay, well, a) what now? Where do we

go from here? And b) sort of recognising that, okay, we've reached this pinnacle position.

So, it kind of started a shift in our work, that moment of introspection, that searching for how we can make deeper imagery. How can we make imagery that speaks to us more and that we find more fulfilling? And that has helped to guide us into making what we feel is deeper work. And by deeper I mean more interesting and impactful. Not just eye candy, right? Not just the epic. It's not to say that we can't still do that, but we want to do something else. We want to make photos that mean something.

Before we move on, there's an important point we want to visit. Even though we're talking about niching and making yourself unique, we don't mean to say you should be an island. You don't have to soldier on alone. Community is important.

FIND YOUR COMMUNITY

Isolation is one of the biggest problems that photographers can face. Running your own business, not having colleagues, and working from home on your own are all contributing factors. When one feels isolated, it can lead to a lack of inspiration and energy to create, and, for some people, even depression.

Photography can be a lonely job! As photographer Scott Johnson comments, 'I mean, I'm a people person, man. This is quite a solitary job. I'm up here by myself most days, just editing and working away. But when I get out, I can interact with people

and have fun and have a bit of a laugh with people, which is what it's all about.'

It is important to stay connected to your professional community, to keep yourself inspired and energised. When you're engaged with your peers, you have a healthy support network whom you can reach out to for conversations and advice.

Here are four simple tips:

Join a co-working space

If you find working from home too isolating, joining a co-working space is a great way to work in a more stimulating environment. In Melbourne, Australia, there has been significant growth in co-working spaces catering for creative professionals such as stylists, designers, photographers and videographers. A permanent desk starts from around A$800 per month and many of these co-working spaces have monthly events designed to help entrepreneurs network and grow their businesses.

Join a professional association

A professional association is an industry body that supports photographers and serves to advance their professional interests. They provide training, certifications, resources and events to help photographers advance their skills and capabilities. Professional associations include the Australian Institute of Professional Photographers (AIPP), the British Institute of Professional Photographers (BIPP) and Professional Photographers of America (PPA).

Join an online group

This could be an online MeetUp, Facebook or LinkedIn group. Not only are groups great for engaging in online conversations,

they may also organise offline events for networking and learning. Some photography products and solutions have members-only groups that also make for great community forums to ask questions, seek advice and meet up with fellow photographers. For example, Studio Ninja has a Facebook group with around 7,000 members, made up of many photographers and videographers. They share industry knowledge and exchange recommendations on a wide variety of business information such as workflows and suppliers.

Growing your own business can be an incredibly lonely journey, so find a small business or entrepreneurial community. Go to start-up events. Get to see how other businesses run. Share your experience with other entrepreneurs on the same journey.

Build a team of advisors

Get help from mentors, business coaches, photography coaches and trusted friends who have successfully built businesses. They don't have to be photographers! The ingredients that go into making a business successful are the same across different industries.

SHOOT LIKE A NINJA: CRAFT YOUR NICHE

We've covered a lot in this first step, so here's a quickfire summary of the key points to remember and revisit in this chapter:

- Discover your niche to stand out from the crowd.
- Tell your story to communicate your core values.
- Consider your archetype to help build your brand.
- Identify your ideal customer so you can create a customer persona.
- Develop your product niche to offer something out of the ordinary.
- Build recognition through a variety of credibility-boosting activities, such as winning awards, getting published, running workshops and speaking at events.
- Find a community that supports you and sets you up for success.

STEP 2:

CAMPAIGN AND ATTRACT

Perfectionism is often an excuse for procrastination.
Paul Graham
Co-founder of the influential start-up accelerator
and seed capital firm Y Combinator

One of the biggest reasons that photographers don't succeed is a fear of and lack of marketing. They would rather spend time retouching their portfolio and updating their website with new work than putting out a Facebook campaign, creating partnerships and writing blogs.

Do yourself a favour and write this down on a bright Post-it that you can see every morning:

I must spend more time marketing now so I can spend more time shooting later!

We can't stress enough how important it is to have a plan, especially when it comes to marketing. And the first thing it's important to do is set your goals.

SET YOUR GOALS

Goal setting doesn't have to be a painful process, but there's no

point setting wishy washy goals with no clear timeframe or way of measuring your progress as you go about achieving them. The best goals are solid, concrete scenarios that motivate you to do the hard work needed to get them in the bag.

One of the best ways out there to help get your goals down on paper is to use the SMART method – a common way of articulating what you want to achieve, first developed by George Doran, Arthur Miller and James Cunningham back in 1981. If you look up SMART goals online, there are a few different variations now, but with the common aim of forming manageable and meaningful objectives.

SMART goals are:
S: Specific
M: Measurable
A: Attainable
R: Relevant
T: Timebound

To be specific, the goal needs to name the objective to be accomplished and highlight what actions will be involved in achieving it. To be measurable, there needs to be a performance indicator that can be reviewed to show progress. This may be a number of vendors to contact or an income figure to achieve – something that's easy to track. To be attainable, the goal has to be within your power. If the tasks required to achieve the goal are time-consuming and you're fully booked for the next few months, does it make sense to put that pressure on yourself now or do you need to be more realistic? To be relevant, there has to be a benefit to the goal. Is spending the time on social media getting a hundred more followers in March actually going

to benefit your business in the long term? If so, great! If not, time to rethink the goal. Finally, to be timebound, there has to be a deadline, a timeframe that makes the achievement mean something. If you are aiming to double your revenue, given the constraints, how long do you want that to take?

You can see now that a goal such as 'get more customers' just doesn't fly. Be specific. How are you going to get them? Make it measurable. How many new customers do you want? Make it attainable. Given your niche and marketing budget, are you going to be able to reach the number of people required to convert that many into new clients? Make it relevant. Will this number of new customers help your business prosper, or will the associated costs mean you end up making the same or even less profit? Make it timebound. How long do you have to get this number of new customers for it to benefit you – are we talking weeks, months or years?

Also, remember that your goals don't have to be set in stone. You can revisit them – over and over, revising them as you go, and setting new ones while you tick the existing ones off your list.

Exercise: Goal setting

Grab your notebook or hop onto your laptop and open a spreadsheet – it's time for some sums!

These are the top five questions you must ask yourself:

1. *What are my costs per job? Consider costs related to your products, time and equipment.*
2. *How many hours are required to complete a job?*
3. *How much do I want to make?*
4. *How much do I want to charge? Here, as well as being led*

by your answer to question 3, you'll want to consider the
market rate for services similar to yours.

5. How many clients do I need? In its simplest form, this could
be the answer to question 3 divided by the answer to question 4.

You could switch the last few questions around as well,
depending on your situation. So, you could ask how many clients
you want to work with in a period, then how much you want to
make. The latter divided by the former may indicate how much
you should charge. But again, you'll want to take the competition
into consideration.

Keeping the answers to these questions in mind will help
you set realistic and measurable goals. Ask yourself: When do I
want to achieve my goals? (How many hours do I want to put in?)
Using the SMART framework, you can then articulate your aims.

One goal might be: To book in six clients in the next six
months for my $3,000 package, by offering a promotional discount code to thirty florists in the region, ten of whom I have
an existing relationship with, and dedicating $500 to a Google
advertising campaign.

Whatever your goal, ask yourself:

- Is this specific?
- Is this measurable?
- Is this attainable?
- Is this relevant?
- Is this timebound?

If an element is missing, tweak your goal until it fits the bill.

So far so good! Once you know your goals, you can put a plan in place to achieve them in your desired timeframe. You can figure out the actions you need to take and milestones you need to hit to get there, and start tracking your progress.

CREATE A SIMPLE MARKETING PLAN

A marketing plan allows you to write down everything you are doing and thinking about doing in marketing. Once written down, it gives you the ability to assess whether your plan is realistic and achievable with your limited time and money.

A marketing plan does not have to be complicated! It can be done in a day.

Start by asking yourself the following questions:

- What is my annual target?
- What channels is my ideal client using?
- What is my annual budget?
- How much time can I give to marketing?

Set annual and quarterly targets

Set an annual target for both sales and leads that you need to generate from your marketing activities. Say you're a wedding photographer and you're aiming for thirty weddings in a year. You know from experience that you book roughly one wedding successfully for every four enquiries (leads) you receive. That means your conversion rate from leads to sales is twenty-five percent.

Annual sales target: 30 weddings
Conversion rate: 25%

Annual leads target: 120 leads

Quarterly leads target: 30 leads

As we'll talk about in more detail soon, it is risky to attempt generating all 120 leads from a single campaign or channel, making the target likely unobtainable. A safer way is to generate your leads from a variety of sources, spread out over time. If you're aiming to acquire 120 leads over four quarters, you have a quarterly target of thirty leads.

Why have a quarterly target instead of a monthly target? It is easier to break up one year into four quarters, rather than twelve months, because some campaigns take time to produce leads, and a month can pass too quickly for any results to eventuate.

Now that you have established your quarterly leads target, you can look into identifying the best channels for acquiring these leads. This takes us back to the work we did in step one, on our ideal customer and where to find them.

Identify your preferred channels

Earlier in *Step 1: Craft your niche*, you established your ideal customer persona. Let's go back to the channels you identified. For each channel, you determined the destination where your client would most likely make an enquiry, and also identified the content that you would need to create in order to engage your client. The next step is to add to your table your target leads, dividing these between the different channels.

Here's the example again:

CHANNEL	DESTINATION (point of enquiry)	CONTENT REQUIRED	TARGET LEADS
Referrals	Website/ Facebook/ Instagram	Timely response to incoming messages/ email	8
Google Organic Search	Website	Landing page which is ranking well for 'wedding photographer Byron Bay' or 'family portrait photographer Byron Bay' or 'pet photographer Byron Bay' etc.	5
Google AdWords	Website	Search ad and landing page	5
Facebook	Facebook business page	Facebook ad and video	5
Instagram	Instagram profile/ Website	Instagram posts or reels	5
3rd Party Blogs	Website	Guest blog articles, e.g. 'Top 5 mistakes to avoid when hiring a wedding photographer'	2
			30

Diversify your lead generation

As we've mentioned, it doesn't pay to put all your eggs in one basket. Make sure you have leads coming from all possible channels and sources, including word-of-mouth referrals, social media, directories, events and a website that is well-ranked for important internet search keywords.

Successful photographers rely on a variety of marketing channels for leads. It is unrealistic and stressful to think you can generate all the leads you need in one year from one single channel or from exhibiting at one expo.

It's a myth that there's one marketing solution to all your sales problems. There ain't no magic bullet! We have this idea that one campaign is going to do it, or we're going to hit this curve at some point which is exponential, and you will just go boom and get big suddenly. But actually that rarely happens. What happens instead is just this constant stream of a dozen different marketing ideas all working at the same time. Every month there's something that we're doing, or we could be doing three or four things at the same time. We're not generating all the leads from one source. Instead, we're generating a great pool of leads from half a dozen to a dozen different ideas.

Andrew Hellmich on generating leads:

I think what photographers, even more established ones, tend to do is go looking for this Holy Grail, this one marketing idea that's going to take their business to this new level. This one strategy that's going to bring in all these clients. They're looking for one solution to make their business amazing. The truth is it doesn't exist. There simply isn't one.

The best photographers, the most successful photographers, will have six or seven marketing irons in the fire at the same time, all the time. There are leads coming in from email, from Facebook ads, from Google ads, from referrals, from the Bridal Expo, from vouchers through third party marketing, from partnering with the local school. There are so many things you can do. To rely on one is crazy.

Set your budget

Okay, now let's think about your budget. How much budget are you willing to spend on marketing in a given year? This includes any advertising spend, directory fees, costs of exhibiting at an expo, and website design and development costs. It does not include your time costs.

Say your annual marketing budget is $2,000; this means you have a quarterly budget of $500. Next, we will work out the time you're able to spend on marketing per quarter before we add both budget and time columns to the earlier table.

Allocate time to marketing

Think for a minute. How much time are you willing to spend on marketing in a given week? It is easier to think about your availability on a weekly basis because you likely have an established weekly routine that works for your lifestyle.

Say you dedicate every Tuesday and Wednesday to marketing tasks and activities; this means you have around fifteen hours per week, which equates to about sixty-five hours per quarter.

We're now going to add both budget and time columns to the marketing plan.

CHANNEL	DESTINATION (point of enquiry)	CONTENT REQUIRED	BUDGET	TIME	TARGET LEADS
Referrals	Website/ Facebook/ Instagram	Timely response to incoming messages/ email	-	8 hours for general upkeep	8
Google Organic Search	Website	Landing page which is ranking well for 'wedding photographer Byron Bay' or 'family portrait photographer Byron Bay' or 'pet photographer Byron Bay' etc.	-	10 hours for copywrit-ing and creating page	5
Google AdWords	Website	Search ads and landing page	$250	10 hours for creating and monitoring ads	5
Facebook	Facebook busi-ness page	Facebook ad and video	$250	10 hours for creating and monitoring ads	5
Instagram	Instagram profile/Website	Instagram posts or reels	-	12 hours for creating weekly posts	5
Blog	Website	Guest blog articles, e.g. 'Top 5 mistakes to avoid when hiring a wedding photographer'	-	15 hours to write 3x articles	2
			$500	65 hours	30

Measure and improve your plan

Wahoo! Now that you have a quarterly marketing plan, it will be much easier to stay focused on your marketing to-dos. A quarterly cycle keeps you on track for the annual sales target without overburdening you with the task of coming up with an annual plan. A quarterly plan also allows flexibility for things to change, where learnings from each quarter can be used to improve the next quarter.

But remember – a plan is simply a guide to keep you focused on your goals. You may realise that you need a lot more time or money in a particular channel, and you may have to sacrifice something. Or perhaps you discover it was unrealistic to attempt to generate as many leads as you initially thought from one particular channel. The plan should be refined over time as you learn from your mistakes and update your strategies. This means more wins for you!

Make a habit of asking every new enquiry how they found out about you. If you're acquiring enquiries via your website, make sure you have a mandatory question or field in your contact form that asks the enquirer to select from a list of potential channels. If you receive an enquiry via phone or email, include this question in your workflow or saved email template (more on these later).

Update your plan as you go or, even better, start tracking your performance by entering how many leads you actually generate from each channel every quarter. Keep it up for a full year and you will learn how to reallocate your time and money based on which channels or strategies are giving you the highest number of qualified leads.

 Scott Johnson on marketing:

My goal moving forward is to be better at marketing... just continue pushing the pricing up and shoot fewer weddings. At the minute, it's good. Business is good. The ambassadorships that I'm working with at the minute are good. I've got a lot of exposure from that. The training side is going well. We offer training courses now. I'm going to try to push a bit more of that. As far as the photography goes, I'm at a really great place at the minute. It's going to be a bit of a flat year in the UK for weddings. Industry's falling flat at the minute, but we're due a crap year anyways. We're just moving forward. So, I'll just try to continue to push out the good work and make people happy.

Now that you have a marketing plan in place, let's drill down and look at one of the most important points of enquiry in a bit more detail – your website. It could be argued that all channels lead here one way or another, since your socials, any articles and, ideally, referrals should all mention your website, allowing your customers to visit your home on the web.

BUILD YOUR WEBSITE AROUND YOUR IDEAL CLIENT

Most photographers have portfolio websites. And hey, we get it. A portfolio website is designed to focus the attention of the visitor on the photographer's work. A common site structure involves a homepage with an image slider featuring their best work, a

more detailed portfolio section showcasing a variety of albums, a content page about the photographer's story and a contact form.

But if you want to stand out from everyone else, and if you want to generate more clients and sales from your website, you have to stop making a portfolio website.

Instead, build your website around your core product, whether that's a $3,000 wedding package or a $500 family portrait session. We can't give you better guidance than what photographer and business coach Mark Rossetto has to say on the subject here.

 Mark Rossetto on your website:

Start with the end product in mind. One of the biggest things is the website. Your website is your shopfront. Even if you have a shopfront, your website is still your shopfront. Your website is still the first thing that customers will be going to at some stage.

There are two types of photography websites. One is your basic website, which is what I like to call a portfolio-based website. There's the homepage, there's an 'About Us', there's lots of pretty pictures in the gallery, and there's a 'Contact Us'. Really, there's no proper substance. There are lots of pretty photos. But everyone can take pretty photos. What's your unique selling point and how are you standing out from the crowd? On the other hand, we have an advanced customer-centric website, where you really start talking about the end product in mind, because as photographers, we make money from selling products. Pretty pictures and beautiful products.

On your advanced website, you've got your room views, you've got your client experience, you've got your welcome videos, you've got the products that you sell and the different items that people can buy. You've got videos of products and you're talking about products. You're talking about your unique experience, and you're setting yourself up as being the expert. If you can talk with the end product in mind, not just show pretty photos, it's gonna make your client experience more enjoyable. It's gonna be clearer. You're gonna be more transparent, and you've set up the client's expectations as well, whereas if you're just showing pretty photos and they contact you and you tell them it's $3,000, you're gonna shock the bejeezus out of them, because they didn't actually expect it. Surprises are better for birthday parties!

So, let's drill down into another layer of detail and look at your website's landing pages in particular.

THE ANATOMY OF THE PERFECT LANDING PAGE

For those of you who don't know, a landing page is a standalone page on your website that has been created specifically for a marketing or advertising campaign. It's where your potential clients will land after clicking on a link from one of your referral partners or an email or an ad on Google, Facebook, Insta, etcetera…

Landing pages are different from your homepage. Sure, your

homepage looks amazing. It shows off all your ridiculously awesome photos, typically has a lot of information on it and lets people click around to learn more about you and your business.

Landing pages, on the other hand, are designed to be focused. They complement your marketing efforts and have one goal in mind: to get visitors to complete your call to action. That action could be to contact you, fill out a form, download something or book a shoot, whatever you want them to do!

The absolute best thing you can do is create a landing page for each of the different marketing streams that you've got going on. For example, if you have a pet shop recommending you to new puppy owners, you want your landing page to show pictures of puppies. If a wedding reception venue is recommending you, make sure the landing page shows off how amazingly talented you are at shooting at that particular venue.

Our point is, make your landing pages match your marketing and you'll see your conversion rates go up!

Okie dokie, now that you know what the benefits of a landing page are, let's talk about the structure and what should and shouldn't be included on them.

Header image and headline

People are busy and have the attention span of a goldfish! Okay, that's a little harsh, but if you build your landing page with that thought in mind, you'll be a lot more careful and selective about what you include.

You need to do your absolute best to capture people's attention with your header image and headline, otherwise they'll just move on to the next most exciting thing, like a YouTube video of a cat playing a piano!

You want to choose a header image that not only matches your marketing but also makes you stand out from the crowd. One that will give people no choice but to remember exactly who you are. This image needs to make visitors think, *Damn, I want a photo of me exactly like that!*

You may want to test out your image choice with a couple of friends. Sometimes we photographers can be a little biased and one-sided about how awesome we think our own work is. Getting a second (or even a third) opinion will either confirm that you've made the right choice or shed some light on your work that you simply couldn't see. No one likes to be criticised, but sometimes a little bit of tough love now can save a lot of headaches down the track.

Now let's nail the headline. You need to craft a headline that explains exactly what you're offering. Just like your image, it should match or be very similar to the offer that you are sharing via your marketing channels. It's been proven time and time again, if you show your visitor something different from what your ad promised, expect poor results and a high bounce rate.

Let's say, for example, a venue named ABC Estate is recommending couples to you. Your image and headline should reflect that. Your image could be a stunning photo of a beautiful couple dancing or laughing in front of ABC Estate with the sun setting in the background. Straight away that would capture the visitor's attention and make them think that you're a guru when it comes to this venue.

Next, your headline could say something like:
The #1 ABC Estate wedding photographer!
or

Capturing every beautiful and unexpected moment of your wedding at ABC Estate!

There are a million different ways you can write a headline, but you get the idea.

So, the first mission is to make sure your image and messaging reflects your marketing. You want your visitors to feel like they're in the right place.

The second mission is to make visitors scroll down and continue learning more about you, so let's get into that next.

About you

Clients obviously want to hire you because you're an amazing photographer and you shoot beautiful photos, but they also need to know that you're genuine and that they would feel comfortable with you. This is where the 'About You' section comes into play, so really spend some time and think about what you would like to include here.

This is where you should let your personality shine. Tell people about yourself: what you do for fun, what motivates and inspires you, what quirky traits you have and what makes you the perfect person for the job.

This is also a good time to think again about what kind of clients you want to attract – and the niche you want to work in. If you love rock 'n' roll and spending time in nature photographing weddings in bare feet, amazing, good for you! But you obviously wouldn't want to attract clients who want a Cinderella-style wedding in a big, beautiful ballroom. It's just not going to work.

You want clients who connect with you on a personal level. For example, you may want to attract adventurous, easy-going,

nature-loving clients who will feel comfortable while you show off your grimy feet and toenails!

If you're confident and feel up to the challenge, record a video of yourself. Your video needs to show off your personality, so make sure you get in the zone and give the camera the very best Al Pacino or Julia Roberts that you can muster! If your video is done well, it will instantly get potential clients to fall in love with you. But be careful – if it's done incorrectly, they'll be gone before you know it.

In the next section, we turn from looking at you to looking at your work.

Show off your best work

It's time to show off your best work, although this can be easier said than done. Similar to your header image, you need to choose photos that reflect your marketing. You can do this in the form of a gallery, a slideshow or even links to some guest blog posts you've written for other sites. Just be careful with links to blog posts. This could possibly lower your conversions, as you're sending visitors to other pages.

Let's use the pet shop example again. If this landing page is for new pet owners, you obviously need to show off beautiful photos of pets. But add some combinations too:

- Pets on their own
- Pets with one owner
- Pets with both owners
- Pets with the whole family
- Pets with kids
- Pets with a toy

This variety will show potential clients that this shoot isn't just for a new puppy photo; they can also jump in, and why not bring the whole family? The photos will also inspire or motivate potential clients with different ideas that they may not have considered.

Now that we have our header image, headline, 'About Us' page and gallery sorted, we move on to the next piece of the puzzle: testimonials.

Testimonials

The number one reason why you should include testimonials on your landing page is because it builds trust.

It's likely that the visitor has never met you in person. To build some trust and rapport with your potential client, you should add some real testimonials from past shoots that you've done. An image from a shoot and a quote from the customer works really well, or if you can get a video, that's even better!

Chris's wedding workflow includes an email asking his couples for a testimonial that automatically goes out to them once they've received their photos. This is so convenient. He never needs to think about it; it just happens, on autopilot, and now he has a large library of raving reviews that he can use wherever he likes. Maybe this is something that you want to consider adding to your workflow too.

If you'd like to take this to the next level, you could also include publications or blogs that you have been featured in, any awards that you might have won, or even a screenshot of your testimonials from Google or Facebook to show that you've received X-amount of 5-star reviews from a reliable source. Building trust and showing social proof can be the difference between a potential client filling out your contact form or not, so do it!

Pricing

We're only going to talk about pricing briefly. It is optional when it comes to including it on your landing page, and we're going to talk about its nuts and bolts in a coming section.

For portrait photographers, you may want to outline your pricing model here. For example, is the shoot free and clients can purchase products afterwards, or do potential clients buy a package up front?

And let's say you've offered the pet shop a gift voucher. You may want to reiterate what is included in the gift voucher here in the pricing section.

For wedding photographers, it's your call and it's a bit of a catch-22. If you add your packages, you will automatically filter out the clients who are not in your price range, but at the same time you miss out on potential leads who are just price shopping. On the other hand, if you don't add your packages, be prepared to get a lot of potential time wasters emailing you asking, 'How much do you charge?' Although that is not necessarily a bad thing if you have the sales skills to turn those emails into bookings!

The contact form

Now we're up to the last piece of the landing page puzzle: the enquiry or contact form. There's no question about it, you have to include a contact form to collect valuable information about your potential clients so that you can get the conversation started.

It's important to understand that the length of your contact form could impact the number of leads you get. If your contact form is too long and has twenty questions, there is a good chance you'll get people dropping that straight into the too-hard basket

and not even bothering. But if your contact form is too short and only has three questions, you may get a lot of time wasters. So, you need to try to find that sweet spot somewhere in the middle!

We would recommend starting with the basics:

- Name: (or names if it's for couple shoots or weddings, etc.)
- Email:
- Phone number:
- If you're shooting weddings, you may want to ask about the wedding date, but this is optional. You'd ask this so you can easily check if you're available or not. Alternatively, you might want to leave it out and use that question as a conversation starter.
- Now, we want to learn more about our potential client! For weddings, you might want to ask, 'Tell me about your wedding and what amazing plans you have.' For family portraits, you could say, 'Tell me about your family. What do you guys love to do together and what would you love to get out of this photo shoot?' Depending how they answer, it'll be pretty obvious to you if they are genuinely interested or not.
- Lastly, we'd normally recommend in a contact form that you ask how they heard about you. This is an excellent question for capturing and tracking your lead sources so that you can see where your leads are coming from. Then you can put more effort into the better performing marketing channels and you can also thank the people who have referred you. But wait – because this is a landing page, we already know where these leads are coming from! For example, we know this lead has come specifically from the pet shop, so there is no need for this question

here. Definitely add it to your website homepage contact form, though!

If you are getting too many low-quality enquiries, increase the number of questions and tailor them more towards the type of client that you want to attract.

Now, at the bottom of the form, you'll have a button. A button that stands out, is easy to read and has a compelling call to action always outperforms a simple 'submit' or just 'contact me'. Try using something that's on brand for you, maybe something like:

- Let's rock 'n' roll
- Get in touch
- Let's connect

If you have a photography business app or studio management software, like Studio Ninja, we highly, massively, astronomically recommend that you use and embed the contact form that your app offers you. This will automatically capture the lead into your app, help keep all your leads neatly organised in one place, track where your leads are coming from and set you on a path to success from the get-go.

Alternatively, your website/landing page should have a contact form builder in it, especially if you've built it using Flothemes, Squarespace or something similar. If it doesn't, you'll need to download and install a plugin like Contact Form 7 or JotForms or WPForms.

Before we move on, let's look at a couple of examples of photographer websites.

 Anna Hardy on her website (https://annahardy.co.uk/):

It's honest and it's open; it's instantly clear what I'm all about, what's important to me, and the specific kind of people my photography is for. The right kind of people instantly know they're in the right place.

 Rick Liston on his website (https://rickliston.com/):

I created my website using Flothemes' unlimited design customisation and I freaking love the ability to

bring anything I can fathom into action, yet also have a whole catalogue of stunningly designed blocks on offer for when I'm feeling creatively drained. Flothemes has given me the power to go from idea to beautiful landing page in the space of a few hours and be able to launch new offers, even businesses, pain-free with tremendous efficiency.

 Chad Winstead on his website (https://chad-winsteadphotography.com/):

I love the flow of the homepage of my website. If visitors simply scroll down on my homepage they can get a good idea of our portfolio, the services that we offer, and they can contact us all from the homepage without ever having to click a separate link.

Here are some other sites to compare and contrast. Do you see what elements make these sites work for these photographers?

- Anna Pumer – **https://annapumerphotography.com/**
- Caroline Tran – **https://carolinetran.net/**
- Jennifer Moher – **https://www.jennifermoher.com/**
- Nirav Patel – **https://niravpatelphotography.com/**
- Two Mann – **https://twomann.com/**

Now that we've looked at where your customers are headed, what they're going to find there and how they're going to contact you, let's look at the actual products you're offering them.

PRODUCTS AND PACKAGES

In the first step, we talked about niching when it comes to the kinds of products we offer the customer. Pricing these products and considering whether to package them needs to be part of the plan.

As we touched upon in goal setting, it's important to know your costs first. Next, decide how much you want to make. You can let these two factors dictate your prices and you can let them dictate the number of clients you need to work with in a given period. Alternatively, constraints on how many clients you want to work with, given time, capacity and inclination, may dictate the prices you charge them to make the income you desire, once you subtract the costs.

Regardless of the approach you take, don't let benchmarking yourself against others in the industry be the only factor in how you price. It can be helpful to do competitor research, and some folk out there may offer a range they consider appropriate in terms of guidance, but don't let others knock your confidence. If you're suffering from impostor syndrome, you'll automatically

set your prices lower than the competition and try to compete on price. But as we've discussed, that's not the way to stand out in a healthy market. And in order for your business to be sustainable, you need to set prices that will get you the income you need to live the lifestyle you desire. Your circumstances are specific to you and your pricing is about the value you and only you offer your customer.

 Scott Johnson on pricing:

I have two top-selling album collections, with two different sizes within each collection. These are the ones that I want to sell, and which are priced competitively for my customers. Then I have a cheaper collection that has a nice album, but it's not as nice as those I want to sell. I also have a couple of really expensive ones, which are there purely to make the ones that I want to sell look more attractive on price.

Exercise: Your product plan

Think about your products and list them out.

How are you working out your pricing? Consider starting from scratch and refer to the questions you answered in the goal setting exercise, now applying them to each of your products in turn.

1. *What are my costs per product?*
2. *How many hours are required to complete the work related to each product?*
3. *How much do I want to make from each product?*
4. *How much do I want to charge for each product?*
5. *How many clients do I need to take up each product?*

Remember to flip question 3 and question 5 around if you have a set number of clients you want to work with.

Once you've drilled down and answered these questions on a product-by-product basis, you can compare and contrast the figures. Consider your ideal product mix. As we touched upon earlier, you may have one product that's a loss leader in order to draw your ideal customer to your bigger ticket items. Let considerations like this influence your pricing for each product, as well as keeping an eye on what the competition are up to and benchmarking against market rates.

When you have it all down, recalculate your costs and make sure you're profitable given your product mix and annual/quarterly targets.

Next, consider whether there's an opportunity for packaging... however, remember you might not always want to go with a package. There are arguments on both sides, and it can depend on the products you're offering.

 Ben Hartley on packaging:

How can we maximise our profits? I think a lot of times we get really scared about this. You want me to raise my prices, Ben? You don't know the small town I'm in. You don't know the competition, the saturation, you don't know I've been in business for six months. I can't raise my prices, bro. But increasing your profits doesn't have to be about raising your prices. You can increase your profits simply by restructuring the way that you're packaging your offerings.

 Andrew Hellmich on packaging:

I think most photographers fall into two camps. One is all about à la carte and the other one is packages. They're really the two ways to sell. I've always loved packages. They've always worked for me in my business. I could speak to another ten photographers who swear by à la carte. So again, you know what, I don't think there's a one-size-fits-all.

Certainly, people understand packages and understand when they spend more they're going to get more at a better price, so that's what makes it easier to sell packages. But I think, on the other hand, as long as your products are easy to sell and they are easy to buy, then you can have success either way you do it.

I once did an interview with Nicole Begley. She's a pet photographer and I absolutely love the way that she sells. She'll sell a package at a certain price, let's say it's $1,000. Now the client has to spend $1,000 – they've committed to $1,000. She says, 'Okay, so now if you want to buy an album you can have fifty percent off any album you want.' She just made it so much easier for a client to buy an album.

So now you've bought a package plus an album – you've bought the print box, you've bought the album. And she'll say, 'Now, because you've bought both those, I'm going to give you fifty percent off the wall art collections.' You might go from biggest to smallest or smallest to biggest, but she makes it so easy to sell and, on the other hand, so easy for the clients to buy. It makes sense for them to keep spending. That is success.

Phew, we've now covered the basics of having a marketing plan that delivers! But how can you up your marketing game and get leads knocking down your door? It's time to talk strategy.

We assume you already have some strategies in place, otherwise you wouldn't be in business, but these tips and tricks will get your creative juices flowing and open your mind up to a lot of different possibilities.

Best of all, they are tried and tested, by Chris and a lot of other photographers. We know they work really well and they're super easy to implement.

So, let's dive straight in.

SCALE YOUR PHOTOGRAPHY BUSINESS WITH GIFT VOUCHERS

We'd like to share a story here, something that Chris did in the early days of running his family portrait business. He had exhausted all the potential clients that were within his 'inner circle' of family and friends, so it was time to step on the gas, hustle and find some new clients!

He started thinking of all the different businesses that could potentially refer clients to him. The first idea hit him like a sack of potatoes. Are you ready for this? It was orthodontists! Of all the businesses in existence, for some strange reason the idea of orthodontists just landed in his head.

So, this was the idea. Someone has been wearing braces for two years. They've been shy, they've been hiding their pearly whites, they may have even lost their mojo and been feeling self-conscious. But now, today is the day their braces come off.

Suddenly, we have someone who is beaming! Their confidence is through the roof, they're smiling from ear to ear. What a great opportunity to do a photoshoot! Boom, the idea was solid.

The plan was for the orthodontists to give out a gift voucher of Chris's to every patient who finished their orthodontic treatment. That voucher would entitle them and their families to come in and enjoy a photoshoot and get an 8" x 10" framed print, all valued at $395, for FREE.

The result: The patient is super happy because they get a free photoshoot at a point in their life when they are feeling awesome and wanting to show off their brand new, beautiful smile. The orthodontist is super happy because they're providing more value to their patient by giving them a free photoshoot. And Chris is super happy because he gets a new customer. It was a win-win for everyone.

So, Chris got to work. There's no secret sauce here, folks; you grab a cup of coffee, turn off your socials, put your phone on flight mode, put your head down and just get busy. Chris spent the day finding, researching and emailing orthodontists all around the Melbourne area. It was a grind, but by the end of the day he had sent just over 200 emails. *A solid effort*, he thought to himself, *so let's call it a day.* And he signed off.

The next day he woke up and had three replies. Three orthodontists liked the idea and wanted to meet up. Chris met all three that week. They loved the idea, they loved his enthusiasm and they agreed to give it a go.

Chris quickly designed some gift vouchers, printed them off at a local printer and dropped them off at each orthodontist. The next day, his phone rang and he booked his first 'real' client.

Here are a few other scenarios that could get your creative juices flowing:

- Imagine someone has just finished a twelve-week fitness challenge and they're looking and feeling better than ever. Maybe the personal trainer could give them a gift voucher – it could be a great opportunity to get a photoshoot.
- Imagine someone has just bought a new puppy. Maybe the pet shop owner or breeder could give them a gift voucher – it could be a great opportunity to capture the new arrival to the household.
- Imagine someone has just bought a new home. Maybe the real estate company could give them a gift voucher – it could be a great opportunity to get a new family portrait done to put up on the wall in their new home.

Now, we know there are a lot of different ways to run a portrait photography business. You may sell packages upfront, you might do photoshoots for free and sell products afterwards, or maybe you have a subscription model and charge families a little bit on a monthly basis and in exchange do regular photoshoots for them. Regardless of your business model, these ideas and others you brainstorm can get you thinking and get your creative juices flowing with new marketing possibilities.

Exercise: Creative marketing

Using the ideas above for inspiration and then thinking outside the box, get creative and come up with a set of marketing campaigns that may work for your business. Mind map them out

*with pen and paper and cast a wide net – the more ideas you
have to choose from the better.*

Next, let's rank those campaigns. Take the following steps:

1. *Write down ten of the creative marketing ideas you've come
 up with, or as many as you can.*
2. *Give each idea a rating between 1 and 10 for 'Impact'. 10
 means this idea would highly impact your goal, e.g. reach
 many customers, make lots of sales, make customers
 exceedingly happy, etc.*
3. *Give each idea a rating between 1 and 10 for 'Ease'. 10
 means this idea is the easiest to execute, e.g. cheap or no
 cost, takes very little time, etc.*
4. *Add up the score for each idea.*
5. *Rank the ideas from highest to lowest.*
6. *Start your action plan with the idea with the highest score
 and work your way down.*

Always think back to your ideal client. Who are they? What
do they do? Where do they hang out? What do they like buying?
Once you've answered those questions, get out there and start
building relationships with their suppliers. Maybe they'd love to
refer their clients to you if the offering is right!

SCALE YOUR PHOTOGRAPHY BUSINESS WITH REFERRALS

As the old saying goes, 'It's not what you know, it's who you
know,' which, in this case, basically means building relationships
and getting referrals. Everyone knows that word-of-mouth is

one of the most powerful types of advertising, so how do we make it happen?

To get an idea of how best to attack this strategy, we need to break down the booking process from your client's perspective.

For someone looking to get married, in a nutshell, it looks kind of like this:

Stage 1: Get engaged
- Buy an engagement ring
- Book a hotel, resort, dinner, boat ride, something romantic, etc. and propose!

Stage 2: Confirm a date
- Book a reception venue
- Book a ceremony venue (if it's different from the reception)

Stage 3: Book the suppliers
- Book a photographer
- Book a videographer
- Buy a dress/suits
- Buy a bouquet and flowers
- Buy a wedding cake
- Book a marriage celebrant
- Book music/entertainment
- Book wedding cars

You get the idea. So, the mission here is to get as many of these businesses to refer clients to you as possible. But how do we do that?

We've put together ten different ways to do this, and a lot of these ideas will also apply to portrait photographers, so listen up.

1. Create an 'inner circle'

If a potential client sends you an enquiry and you're already booked, what do you do?

Wouldn't it just be amazing if you teamed up with one or two other photographers and recommended each other if you were unavailable on a particular date? This one strategy alone could completely fill your diary.

2. Make friends with vendors while you're on the tools

There are plenty of opportunities to joke around with the celebrant before the wedding, rub shoulders with the videographer while walking backwards up the aisle, or smash a beer with the band or DJ in between sets.

Make an effort to get to know the suppliers and if the relationship grows, you could start sharing referrals with one another.

3. Stop lurking, start posting on the socials

Get involved, participate in the conversations, ask questions, answer questions, give feedback. Slowly get to know your industry buddies in these online social groups.

After a while you will see relationships beginning to form and, again, maybe you could end up sharing referrals with one another.

4. Rock up to industry events and mingle

Go to expos, networking events, information nights and parties. These are great opportunities to mingle and exchange war stories with like-minded people and, as I keep mentioning, maybe you could end up sharing referrals with one of them.

5. Tell someone you like them

Let's try doing it the old-fashioned way. Find a supplier that you would love to partner with, tell them that you love their videos, flowers, dresses, whatever it is that they do, and offer to buy them a coffee and have a chat. Easy peasy.

If things go well, you've just created a new friendship and potentially a new partnership and can start sharing referrals with each other.

6. Shoot with the supplier in mind

Every time Chris is out shooting a wedding, he's always thinking in the back of his mind, *Which suppliers would like to receive these photos?* For example, he could send close-up photos of the bride to the makeup artist, he could send photos of the flowers to the florist, funky shots to the band, scenic shots to the venue – you get the idea.

If you can find the time and just spend an extra minute taking photos with the supplier in mind, they will be absolutely thrilled to receive these photos and you'll be one step closer to getting on their preferred suppliers list.

7. A favour for a favour

Every year Chris offers a few wedding dress designers a free photo shoot. Sure, shooting for free sucks, but a dress designer might sell 300 dresses a year and if they can personally recommend Chris to 300 brides, he'd say that's a pretty good deal!

Another idea is to offer a wedding celebrant some new headshots, for free. It'll take an hour or so of your time, and it'll give you guys an awesome opportunity to bond and laugh and hopefully they'll be so happy with the results that they'll refer you to their clients too.

8. Sweeten the deal

There may be a situation when the vendor is a little more commercially inclined and simply giving them love is not enough. In this case, you have two options:

Option 1: You could offer their clients a discount. For example, if a supplier refers clients to you, you could offer those clients ten percent off your photography packages. The result is that the vendor looks great because their customers are getting an awesome deal, the couples love it because they are saving money, and you're happy because you're getting more leads. It's a win-win for everyone!

Option 2: You could offer to pay a commission back to the vendor. For example, if a supplier refers a client to you and you book the client, you could pay ten percent commission back to them. This might incentivise them to refer more couples to you because they get paid, essentially earning passive income for doing nothing.

9. The gift

This strategy is very similar to the orthodontist example that we mentioned earlier. Chris once partnered with a jewellery shop and the deal was that every time someone bought an engagement ring, they would receive a 'gift' from the jeweller, which was a free engagement shoot. Another win-win for everyone.

The couples loved receiving this gift. The jeweller looked great because they were adding value to their customers' experience. And finally Chris was happy because he got to photograph newly engaged couples who were looking for a wedding photographer. Nine times out of ten they loved their free shoot and booked Chris straight in for their wedding.

10. Give, give, give, receive

Another really nice way to create business relationships with other suppliers is to refer your clients to them first! There was a band that Chris loved working with and whenever they were at a wedding together, they always had an absolute ball. So, any time a couple asked Chris if he knew any good bands, he would instantly recommend these guys; it was a no brainer. After three referrals, the band got in touch, thanking him so much for referring couples to them. They added Chris to their preferred suppliers list and started returning the favour. Boom, another win!

Having looked at all these ways to drum up leads, the next step dives into capturing those leads and creating an experience for your clients that will make it almost impossible for them not to book you!

SHOOT LIKE A NINJA: CAMPAIGN AND ATTRACT

Again, we've been on a bit of a journey in this step! Here are the quickfire key points to retain and revisit in this chapter:

- Set SMART goals to make your objectives manageable and meaningful.
- Create a simple marketing plan by setting annual and quarterly targets, identifying the channels you want to focus on. Remember, don't put your eggs in one basket! Diversify your lead generation and take advantage of multiple channels. Set your budget and figure out where it best works for you by monitoring the results. Allocate time to marketing now so you can spend more time shooting later! And measure your progress so you can improve your plan.
- Build a results-driven website that makes your ideal client feel at home. Design amazing landing pages that match up with your marketing!
- Make sure you're pricing your products appropriately and decide whether packaging is right for you.
- Ready to grow? Scale your photography business with gift vouchers and referrals.

STEP 3:

CONVERT AND CLOSE

A good system shortens the road to the goal.
Orison Swett Marden
American author and founder of SUCCESS magazine

When there's so much to do in marketing, it's easy to get distracted. You can spend three hours a day creating posts for social media to get more likes and followers, but is that a good use of your time? Do more likes and followers really convert into more sales?

There is a common belief that more brand awareness leads to more sales. This is why the biggest companies in the world spend billions on television advertising. Ads that air during primetime are seen by more people, which leads to increased awareness of the brand name, which leads to more customers recognising the brand name and thus buying the product on supermarket shelves or in retail shops.

However, that's not always true. A photographer whose Instagram account has 10,000 followers will seem to be generating more brand awareness than one with 2,000 followers. But does the former generate more clients and sales due to having 8,000 more followers? It depends on who those followers are, and

whether you think a client is more inclined to choose the former photographer simply because he or she has more followers on Instagram.

More likely, the client will choose the photographer who:

- Came highly recommended from someone they know
- Pitched the more remarkable package for what they were looking for
- Got back to their initial enquiry the quickest
- Impressed the most in their communications and meetings
- Made the strongest connection with them personally

With that in mind, the best marketing strategy is focused on the first goal – getting that initial enquiry so the rest of your workflow and personality can kick into gear.

You need laser-like focus to ensure your marketing channels convert into enquiries. So, stop trying to get more likes and followers, and spend more time and money on strategies, campaigns and ideas that generate enquiries from the clients you want to attract.

EASILY CONVERT LEADS INTO PAID JOBS

The first thing we need to be able to achieve this is to have a system in place. I know, I know! I know exactly what you're thinking. You're thinking, *Boring! Systems are for losers! They're too rigid! They mess with my creative brain! They're not in line with my free-flowing Zen!*

Don't worry, you're not alone. Chris used to think the exact same way until he looked in the mirror, and there, staring him in

the face, was a tired-looking dude with big dark circles around his eyes and a head half covered in grey hair. *How did it come to this?* he thought to himself. He finally realised that keeping track of everything was just way too stressful and it was time to make some changes.

Now, Chris has a system in place that keeps track of all his leads, jobs, invoices, contracts, and so on. It makes it so much easier to book new clients and nurture current clients. And, best of all, it automates eighty percent of his admin so he can chill out and relax, knowing that there's a system working in the background taking care of everything for him.

Rebecca Colefax on having a system:

So, the one thing I would have done sooner, I think, is implement Studio Ninja in my business earlier than I did. And the reason I say that is I had my whole business in my head. At one point I had a maternity session booked for a client – a sunrise session, which meant that I had to meet the client in the car park, near the beach in the dark. Then we were going to go to the beach and wait till the sun came up over the horizon to get these magical shots. But I went to bed not even thinking about the shoot in the morning. And I got a call, when it was still dark outside, saying, 'Where are you?' I was still in bed, had nothing prepared. I had completely let my client down. And I have never been so devastated for my client, for myself. I was embarrassed.

I had been researching CRMs for ages. I'd trialled many systems over a number of years. And Studio

Ninja was just so simple and so easy to use that I said, 'Right. I need to get all of this out of my brain,' which was very fuzzy after having three children, let me tell you, 'and then get it into a system where I'm notified what's going on.' Now, I know what's happening. My workflows are the same. Every single time, I can tick off tasks to make sure I know where exactly I'm at. And I have never missed a beat since.

It took me a long time to actually say that I needed this because I didn't know I needed it until that moment. And I think I got so busy, wrapped up in photography, equipment props for newborn shoots, doing seminars, doing courses, all that kind of thing. If I had my time again, I would probably just focus on using my camera and get Studio Ninja dialled in because, honestly, those two things are the only things that you really, really need.

It's time to get your life back, so without further ado let's dive into all the tips, tricks, strategies and fun things that you can do to completely transform the way you run your business.

AUTOMATICALLY CAPTURE LEADS

As we mentioned in Step 2, one thing that we highly, highly recommend is to capture your leads using the contact form provided by a photography business app, like Studio Ninja. This will not only save you time because you don't have to double-handle your clients' info, it will also prevent mistakes. It will automatically

bring the new lead into your system; it will automatically trigger a series of events; it will automatically track where your leads are coming from; and it will make sure that everything in your business is neat and tidy and nicely organised from the very start of the process. All of these things can happen in the background without you having to lift a finger. It's the first win!

Speaking of the first win, during his 2014 University of Texas commencement speech, US special operations commander admiral William H. McRaven said, 'If you want to change the world, start off by making your bed.' If you make your bed in the morning, you have accomplished the first task of the day. This small win will give you encouragement and motivate you to accomplish the next task, and the next one after that. It's amazing how such a simple activity at the start of your day can set you up for success and make such a profound impact on the rest of your day.

Maybe it's not as profound, but the simple task of capturing a lead straight into your photography business app is you accomplishing that first task and getting your first win, just like making your bed. That first task puts the wheels in motion and sets up you and your lead for success throughout the rest of the process.

SPRUCE UP YOUR 'THANK YOU' PAGE

Now that we've drilled this contact form stuff deep into your brain and you understand the importance of using a contact form that links directly into a photography business app, we'd like to share a little hidden gem with you.

This little hidden gem is a page on your website that is a goldmine of opportunity waiting to be tapped into. It's not your packages page, it's not your 'Contact Us' page...

It's your 'Thank You' page and it's the next piece of the client nurturing puzzle.

As you're probably already aware, a 'Thank You' page is the page that you redirect your potential clients to after they have completed your contact form. Often, its only purpose is to say a humongous thank you.

While there is nothing wrong with a page like this, it does ignore an important principle in consumer psychology: the fact that people tend to behave in ways that are consistent with their previous actions. In other words, if someone completes a little task, like filling out your contact form, they are inclined to complete another similar or even larger task for you again.

So, picture your potential clients having filled out your contact form and landing on your 'Thank You' page. They're itching to do something similar or bigger but they're just sitting there, twiddling their thumbs because there's nothing for them to do!

There was a really interesting study done by researchers Jonathan Freedman and Scott Fraser, who wanted to test this theory (https://psycnet.apa.org/record/1966-10825-001). Jonathan posed as a volunteer worker and asked people to display a cute little three-inch sticker on their car that read, 'Be a safe driver.' A simple request, nothing that you would lose sleep over, and it turns out these people felt the same way. Almost all of them said yes.

But here's the interesting part...

Two weeks later, Jonathan followed up with these people and asked them if they would mind displaying a large, ugly,

public-service billboard with bad lettering on the lawn in front of their house.

The result?

If you asked us, we would say, 'HELL NO, get your stinky billboard away from my house!' But it turns out, this time, these people didn't feel the same way. Seventy-six percent of them agreed to the request. SEVENTY-SIX percent of them agreed to display that filthy billboard in front of their house! Fascinating!

Which brings us back to your 'Thank You' page, a page that with just a little bit of TLC can bring your potential clients one step closer to booking you.

So, what on earth should this page do? Apart from simply saying thank you for completing your contact form and saying you'll be back in touch with them as soon as possible, here are some additional ideas that you could slap on there too:

Show viewers a video

Not only do videos grab people's attention, they keep it too. Videos are one of the most engaging mediums you can use. So, if you're good in front of the camera, record a video of yourself saying thank you to your potential client. Tell them more about yourself or what to expect next, or maybe even offer a behind-the-scenes video of you in action photographing a wedding or family portrait.

Ask them to follow you on socials

A really simple task that has a big impact. Once they follow you, they'll continue to see you popping up in their feed, sharing your work, sharing client testimonials, sharing videos of you working, sharing achievements, even sharing your personal life. They'll

get to know you and if they like what they see, you're again one step closer to booking these guys in.

Offer them a free download

If you've created a Top 10 Tips or an Ultimate Guide or a Checklist, for example, this could be the perfect place to share it with your potential clients. You will gain authority by proving that you seriously know your stuff, and they will get a lovely free gift with important information that will improve their experience moving forward. It's another win-win!

Demonstrate authority

This is another great place to show off your accolades. Even if you already show them on your landing page, there is absolutely no harm in adding them here as well. If you've been featured on popular blogs, had your images published in magazines, won awards or been mentioned in the media, then add that stuff here. It doesn't matter if the potential client has seen your accolades before or not. Adding them again to your 'Thank You' page will help you build authority, which translates into the client thinking you're the person for the job.

Link to your best stuff

Now that your potential client has already contacted you, this could be a good opportunity to send them to view even more of your best work. Maybe you can show them links to your top three shoots, or a slideshow of your award-winning work, or a blog post that absolutely crushed it. Think about what else this potential client might want to see that will bring them one step closer to booking you in.

Offer a special or discount

We've left this one till last as we wouldn't say giving discounts up front is always the best way to go but, based on your business model, this could be the perfect carrot to get your potential client over the line.

It's a tricky area in which to find the right balance, as your potential clients may have originally come to you via a gift voucher from an orthodontist or with a special discount from a wedding venue, for example, and you absolutely don't want to give a discount on top of another discount!

But if people are coming to you from other marketing channels, this could be a place to offer a limited-time or limited-spots-left discount, or something along those lines. We'll leave this one with you to mull over.

To wrap this section up, just make sure your contact form builder has this feature. If your photography business app doesn't, you might want to think about looking elsewhere. You're leaving money on the table by not redirecting potential clients to a vamped-up 'Thank You' page.

SCHEDULE AN AUTO-RESPONSE

One last contact-form-related gem for you to consider is your contact form email auto-response. Email auto-responses can be an awesome business tool, when used properly! And we emphasise 'when used properly'.

How many times have you emailed someone and got a reply straight back, making you think, *Damn that was fast, these guys*

are on the ball, only to quickly realise that it's a boring, generic message?

When we see a message like, 'Hi! I received your email. I am so happy you contacted me. I will respond to you within the next twenty-four hours,' we want to scratch our eyeballs out and send them an invoice for the time that they just cost us reading their crappy auto-response.

In contrast, when done properly, an auto-response is the bee's knees, and here are some reasons why:

1. If you literally cannot respond within twenty-four to forty-eight hours, an auto-response is a great way to inform your potential client that there may be a delay in getting back to them because you're so busy kicking ass.

2. Remember that saying: 'Tell them, tell them again and then tell them what you told them'? You can use your auto-response to repeat the awesome action that you added to your 'Thank You' page. Or it can be used to easily point clients to information that may answer a question before you respond: for example, sending them to your packages page.

3. Lastly, your auto-response can be a great way for you to build more rapport with your potential clients and blow them away with your awesomeness and amazing personality.

Speaking of awesomeness and amazing personalities, Chris emailed tons of photographers and scoured the internet, reading cringe-worthy auto-response after cringe-worthy auto-response, hoping that somewhere, somehow, one auto-response would stand out from the rest. He hunted high and low thinking this infamous auto-response didn't exist, until BAM! There it was. He finally found it.

When he saw this auto-response from Stella of Stella Reynoso Photography, he was blown away at how professional and informative and warm and human it was. Check it out:

Well hello there, awesome person!

Thanks for emailing me, but I just wanted to let you know that I'm a bit slow on the uptake right now (catching up from the Three Nails Photography workshop, currently running my workshop, recovering from an injury that landed me in the ER last week, AND having family in town...lol), so give me about 3-4 days to reply before shooting me another email!

I schedule many of my posts on Facebook, or tend to post from my phone during quick minutes of downtime, so while it may seem like I'm always around, I am usually operating out of pocket, and try to only respond to emails when I'm back on a real computer to minimise issues & maximise info.

In the meantime, check out Part 1 of my 3-part blog series detailing my AMAZING workshop experience.

In case you've been wanting to book a one-on-one mentoring session with me, ALL sessions must be booked & paid for by October 31, and completed by December 15. These open-ended, free-for-all type of mentoring sessions will be discontinued once all remaining time slots are full to make way for a NEW type of laser-beam-focused business coaching that I plan to debut in January. If you've heard about the magic that is a Sounding Board Session with me, I highly recommend you jump on and reserve your date

soon before they're all gone. ;)

If you have heard through the grapevine about the LOVE & Cupcakes shop, come and check out what me and my partner Terri have going on right now!

Until then, just sit tight and I'll be cranking out replies as soon as I can get to them. Stella

Honestly, doesn't that response – automated as it may be – make you just love her? Chris was already thinking, *Stella, my new bestie, she is busy and she will get to me as soon as she can, and it's totally cool that I have to wait a little bit.* She already feels more like a friend, because it shows a bit of her personality. Oh, and it has a couple of links for you to check out while you wait. We love it!

So, now that you're inspired, here are a few things you should include in your email auto-response:

1. Show off your personality. Don't talk to the reader like you are a computer robot from the 70s or the first version of Siri. Be friendly and personable, and keep it upbeat.

2. If you will have a delay in your response, tell them. Write a couple of sentences about what you've been up to or what you've got going on.

3. Link to something that may be of value to your client or potential client. Perhaps your Pinterest boards, an 'FAQ' or 'What to Expect' page, the latest project you've been working on, anything!

4. Drop a line of advertising. Link to the upcoming mini sessions that you have planned or a new special that you're offering.

Can you see the difference? Your clients will too. Auto-responses can be totally annoying or all in your favour. It's all about how you write them.

Lastly, auto-responses usually send instantly – the second your potential client fills out your contact form. If you're cool with that, then set up your auto-response within the contact form builder of your photography business app.

But if you'd like to add a little bit more of a human element to your auto-response and delay the email going out, then send the auto-response in five minutes' time, for example, or in an hour. This rule can be set up using workflows in Studio Ninja.

And with that perfect segue, the time has come. Let's introduce you guys to workflows. Workflows can be the powerhouse of your business.

USE A WORKFLOW TO MANAGE YOUR LEADS

A workflow is basically a list of tasks that you need to do and tick off, starting from the very beginning when you first get a new lead, right through to the very end when the job is completed. But it's also so much more than that! When set up correctly, your workflow can run your whole business for you, almost on autopilot.

Workflow tasks should do the following:

- Show you a list of tasks that you have to do for each job that you've got.
- Remind you when tasks are due so that you stay on top of everything.

- Automatically send emails to your clients at different stages through the lifecycle of a job.
- Automatically send questionnaires to your clients.
- Automatically send contracts to your clients.

Here's an example of the Lead Stage of a wedding workflow, created by Studio Ninja ambassador Rick Liston, founder of Wedding Workflows (https://weddingworkflows.com/).

LEAD

Lead created

☰ New Lead Response Send email	⊘ 🗑
☰ Already Booked - Photographer Referral Send email	⊘ 🗑
☰ New Lead Follow Up Send email	⊘ 🗑
☰ New Lead Final Follow Up Send email	⊘ 🗑
☰ Meeting with the couple	⊘ 🗑
☰ Post-Meeting Thank You Send email	⊘ 🗑
☰ Send Quote Send email	⊘ 🗑

The Lead Stage is a part of the workflow that happens before the job is actually booked. As soon as a potential client fills out and submits their contact form, the lead is automatically created in his photography business app, Studio Ninja, and the workflow kicks into gear.

You can see that Rick has set up a bunch of email templates and linked them to his workflow. If he's available for the wedding, he'll tick the first task, which automatically sends the 'New Lead Response' email.

Quick tip! The 'New Lead Response' email is a great way to streamline the process and save time, but sometimes it's not

enough to stand out among the rest.

The rest? What 'rest' we hear you say! Well, we wish that our potential clients were only enquiring with us and us alone because we're so awesome, but the reality is that they are probably contacting ten other photographers too.

So, one amazing way to stand out and grab your potential clients' attention is to respond with a video. You can use your webcam or phone and just record a short, light-hearted video responding to their enquiry. It doesn't need to be complicated; something as simple as this would do:

Hey Rebecca,

It's Chris here from ABC Photography. Thanks so much for your message. I thought I'd record a quick video reply for you to save time. So, awesome news, I'm available for your wedding at the ABC Hotel on the 10th of January and would absolutely love to be your photographer. Check out my portfolio and then schedule a time for me to give you a buzz so we can have a chat about all the plans you have for your big day. I'll chuck a link in the email.

Cheers!

Using the video messenger LOOM is the best, easiest, free way to do this, so go brush your hair, get out of your PJs and start recording some videos.

Okay, back to the workflow. If Rick is not available, he'll tick the second task, which automatically sends the 'Already booked – Photographer Referral' email. It's nice to see that he's created an inner circle group of photographers who all refer weddings to

each other. As we've discussed, this is a low-cost, minimum-effort idea that can create a stream of leads coming in all year round.

You can also see that he has a few follow-ups that he triggers if the clients have decided to ghost him.

The mission here is to get his couples to have an in-person or Zoom meeting with him. As soon as he gets that, he knows the booking is in the bag.

After Rick has had the meeting, he will tick the 'Post Meeting Thank You' task, which automatically sends his couples an email thanking them for their time and reiterating that he would absolutely love to be their photographer. This then leads nicely into sending them a formal quote.

Rick Liston on having a workflow:

I can't begin to describe how integral my Studio Ninja workflow is to my business. After a couple has chosen to trust me with capturing their once-in-a-lifetime moments, I want to do everything I can to repay that trust and that starts with the client journey they go on after they book. With Studio Ninja, my couples are not getting left in the tumbleweed zone; I am there with them every step of the way, making timely and pertinent recommendations to make their lives and wedding planning so much easier.

They get so much value from my workflow that by the time I rock up to their wedding, they are raving fans before I've even taken a single photo. The best part? The workflow is doing all the work for me. Collecting vital information, connecting with my couples, providing them with invaluable advice and resources,

removing my headaches, solving their problems, pre-selling prints and albums – it's like the greatest employee ever, all for the cost of a monthly subscription. I get shivers when I think of operating without it.

Rick's is just one example of what the Lead Stage of your workflow could look like. Have a think about all the different tasks that you do once you've received a new lead. Maybe you need a task reminding you to call your client, maybe you want to automatically email them something, or maybe you want to automatically send them a questionnaire to get more information from them.

The possibilities are endless, but remember, less is more! You don't want your workflow to be a burden or give you anxiety when you look at it, so just add the most important milestone tasks. We don't need to see things like 'grab coffee before meeting' or 'feed kids mid-shoot' or 'GRAB YOUR F'ING CAMERA BAG!'... actually, no, that last one needs to be in there!

Exercise: Your workflow

Grab your notebook and pen and spend a little bit of time having a good think about what the Lead Stage of your own workflow would look like.

Scribble down all the tasks you can think of and then, circling or highlighting, narrow these down into the key milestones you need to hit. The first step is as easy as that! You've just come up with a workflow for your business.

The last part of any Lead Stage is booking the client in and turning this lead into a confirmed job, so let's turn to that next.

SEND A QUOTE, CONTRACT, QUESTIONNAIRE AND INVOICE IN LESS THAN A MINUTE

Chris's client-booking process back in the day could easily be described as the most inefficient way in history to book a new client. Some of you may be able to relate to this!

To set the scene, imagine this scenario. Chris has just met his potential clients for a meeting and it went very well. He sends a follow-up email afterwards saying he loved meeting with them, loved their vibe and would love to be their photographer. Nine out of ten times, his potential clients respond by saying something like, 'Hey Chris, we love your work, we love your vibe, too, and we'd totally love for you to be our photographer. Book us in!'

Woohoo, time to celebrate, right? Wrong! Suddenly Chris would feel a huge cloud of stress coming over him, thinking about all the things he had to do, all the things he needed to coordinate, remember, prepare. The list went on and on, and so, the dreaded process would begin.

1. Create a new quote in Excel.
2. Export the quote as a PDF file.
3. Email the quote PDF file to the client for approval.
4. Chase up the client for approval.
5. Receive client approval.
6. Create the contract in a Word document.
7. Export the contract as a PDF file.

8. Email the contract PDF to the client for signing. Hopefully receive the contract back from the client, who has had to print the PDF file, sign it, scan the contract back into their computer and then email it back.

9. Chase up the client for the signed contract if it hasn't come back.

10. Receive response from client that they're really busy and need some extra time.

11. Chase them up again.

12. Receive the signed contract once the client has spent some time working out how to actually sign the contract.

13. Confirm receipt of signed contract but forget to send them the follow-up email asking them to answer a bunch of questions.

...and on and on and on the process goes. The client can't believe how draining the process is and as for Chris, he's stressed up to his eyeballs and can see in real time the natural brown colour in his hair starting to fade to a dull grey.

Obviously, Chris has come a long way since then. For example, he doesn't leave his camera bag at home any more when he goes and shoots weddings! He also doesn't ask his clients to print, sign, scan and send back contracts.

These days, he spends less than a minute creating and sending his quote, contract, questionnaire and invoice bundle. Not only has he saved himself hours of time and mountains of stress, his clients absolutely love the process now too. They've told him time and time again that out of all the vendors that they've hired for their wedding, the process of booking him and communicating with him has by far been the easiest.

And this is just another reason why it's so important to have a system in place and have your photography business app set up to do all this stuff for you.

To prove to you that we're not kidding, let's quickly jump into Studio Ninja and show how easy it is to create and send a quote, contract, questionnaire and invoice.

1. Show Lead

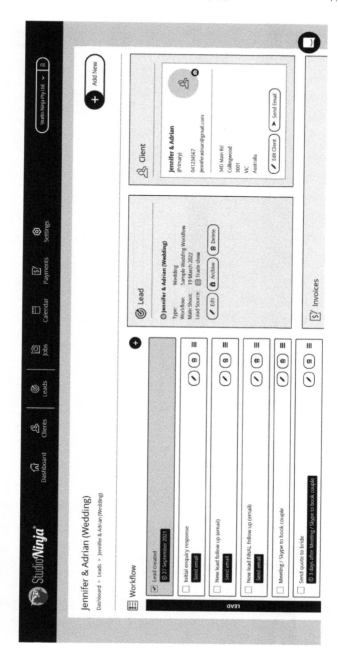

2. Add new Pick & Choose Quote

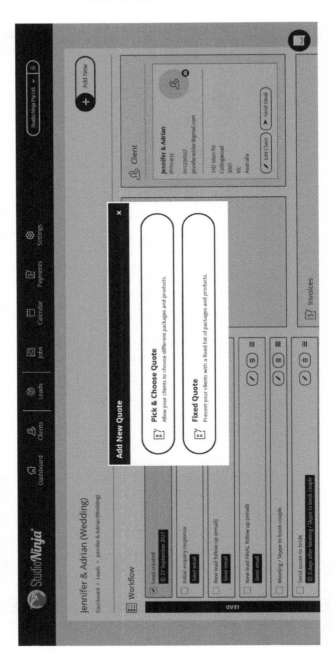

3. Select Quote Template and save quote

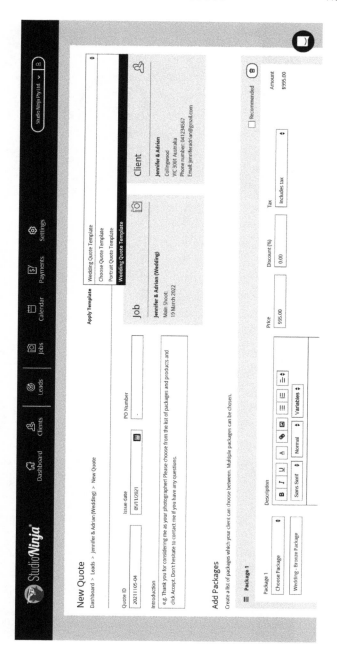

4. Send Quote

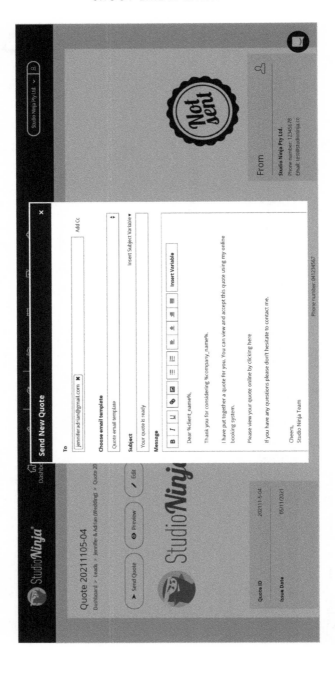

And that's it. Twenty-three seconds!

Now, let's put ourselves in our client's shoes for a second. Let's show you how easy it is for them to book you in:

1. Pick & Choose Quote

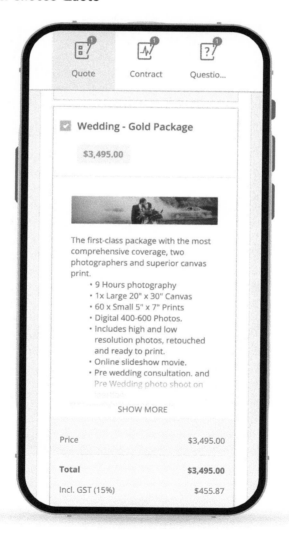

2. Sign Contract

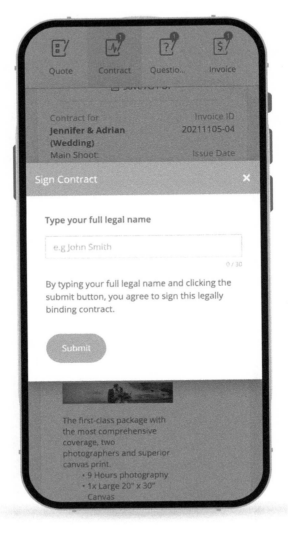

3. Complete Questionnaire

Quote | Contract | Questio... | Invoice

Questionnaire

Thank you for taking the time to complete this questionnaire. Your answers will help me to get a better understanding of your day and plan everything perfectly :-)

Lead Source

How did you hear about us? ▾

Partner 1 Name

Partner 1 Phone Number:

Partner 1 Email:

Partner 2 Name:

Partner 2 Phone Number:

4. Pay Invoice

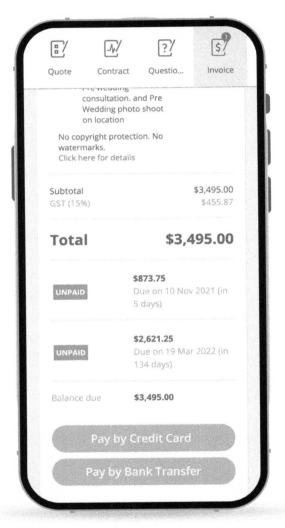

In a matter of only a few minutes, your potential client has turned into a real client!

Woohoo, now we can celebrate! They've chosen their package, signed your contract, answered your questions and paid their deposit all in one go. This is such an easy and convenient experience for them; they can even do it all from their phone while sitting on the toilet. (But we're sure no one does that, right?)

Hopefully you can see the value of having something like this in place in your business. For Chris, it was a revelation. The difference between his old way of booking clients and this new way is so black and white. He has no idea how he even survived as long as he did using the old way.

Think about how much time you would save, how much stress you would remove from your life and how much happier your clients would be if you had a system like this too.

SHOOT LIKE A NINJA: CONVERT AND CLOSE

Hopefully this step has convinced you of the advantages of having a kickass system. These are the quickfire key points to revisit in this chapter:

- Set up a way to automatically capture leads to remove the admin and save you time. The best way to do this is via a photography business app or studio management software.
- Ensure you have a 'Thank You' page your lead goes to after giving you their details – and make it count so they look forward to hearing from you!
- Create an auto-response that shows your personality and actually offers the reader some value to stand out from the crowd.
- Use a workflow to manage your leads and ensure the key tasks and milestones of your process are in there. You'll never have to worry about a misstep when it comes to the customer journey.
- Make it quick and easy to send your quote, contract, questionnaire and invoice by taking advantage of your app.

STEP 4:

STREAMLINE, AUTOMATE AND OUTSOURCE

You don't need more time. You just need to decide.
Seth Godin
Author of eighteen books, including New York Times bestseller
The Dip, Purple Cow and *Free Prize Inside*

Amazing news, you've booked a new client... Now what? Well, now it's time to sit back, relax and let your system do all the hard work for you – all the remembering, all the emailing, all the money stuff. The goal is to set up your business so that you have the luxury to chill out and go drink pina coladas on the beach, while it works in the background doing all the stuff that you don't want to do.

In this step, we're going to give you tip after tip of all the things that you can do to make running your business on auto-pilot possible.

USE TEMPLATES

If you want to start running your business on autopilot or as close to autopilot as you can get, you need to become friends with

templates. Email templates, questionnaire templates, contract templates, quote and invoice templates, and all the other fun templates.

You might think that templates make you sound robotic and your business will lose all its heart and soul if you use them, but that's simply not true. If composed correctly, templates can help you to become more efficient and make fewer mistakes. They can reduce stress, streamline communication with clients and simply just make your life easier! If you want to grow your photography business without increasing the amount of admin, incorporating templates is one piece of the bigger puzzle of making that possible.

How good would it be if your system could:

- Automatically send your client an email a week before their shoot to confirm and make sure everything is on track?
- Automatically send your client a questionnaire asking them important questions about their shoot or which family members they'd like included?
- Automatically send your client a payment reminder email when their invoice is due?

The list goes on...

Although each client is unique and they deserve a personalised experience, when you really think about it, there's a good chance that you actually already send clients the same email over and over again, the same quote over and over again, the same package options, the same contracts, the same questionnaires, and so on. Imagine how much time you would save if you only had to write or create these documents once. Emails could be

automated, you could send quotes with contracts and question-naires attached with one click, and you would save so much time!

Here's one example of an email template – an email that Chris sends to his wedding clients one week before their wedding:

Hey %client_name%,

Wow, you're getting so close – how exciting!

I just wanted to touch base and make sure every-thing is on track as planned. Has anything changed that I need to be aware of?

Also, if you have a second, can you let me know the names (or even Insta handles) of some of your other suppliers so I can tag them if I add any of your photos into a blog post :-)

Dress:

Suits:

Flowers:

Hair & Makeup:

Celebrant:

DJ/Band:

Anything else I'm forgetting?

Woohoo! See you next week!

Cheers,

Chris

Although this is a template, it sounds totally personalised, friendly and like you are actually writing it from scratch for your client. And the best part is that your client will appreciate you checking in on them. They'll feel loved and they'll feel like they're

in good hands because you're on top of things and have every-thing under control.

What's even better, this is all happening on autopilot.

 Tommy Reynolds on automation:

One of my favourite features in Studio Ninja is the automation. I love the fact that I can be sitting watching TV, and then all of a sudden I get an email through from my client saying, 'Oh, thank you so much, Tommy, for sending through the questionnaire, we've signed the contract, here it is.' And I'm like, 'Did I send that? Oh, yeah, Studio Ninja did it for me. Of course.' So having that flexibility, saying goodbye to forgetfulness, is just amazing. It's just been an absolute dream.

Exercise: Your templates

Time to pick up your pen and get brainstorming again. Have a good think about all the things that you send your clients over and over again. Referring to your Lead Stage workflow will help with this – several of the tasks will be about communication, before and after a job's booked in. Jot down all the different emails you send over and over – the welcome email, the quote email, the confirmation email, the chase-up email…

It's time to turn all those things into templates so you can take on more clients and do less work! Take a look back through your emails and see the information and phrases you use over and over. With the help of copy and paste, now write the perfect email – just once! Take each recurring communication and turn this into a template that can be sent automatically as it is or

reviewed by you before it goes, just to fill in any gaps and tailor certain information if that's required.

Talking about templates leads us beautifully into our next topic: nurturing your clients – with automation!

NURTURE YOUR CLIENTS, WITH AUTOMATION

Caring for your customers is kind of like caring for your house plants; if you neglect them, well, they'll die! Obviously, your clients won't die, but your relationship with them will and that is why nurturing client relationships is so important.

In a nutshell, nurturing your clients boils down to delivering an awesome customer experience. This process starts from the second your client first contacts you and continues right through to the very end of the project, and beyond.

In case you're still a bit iffy and not quite sure that providing a stellar customer experience is important, let's list out five reasons why you NEED to get this right. If you're not stepping up and delivering that next-level customer experience, it could be the difference between you running a successful photography business or not. You have to focus on serving your customer:

- To gain customer loyalty and trust.
- To become refer-able.
- To be able to charge the prices that you want.
- To be oversubscribed, with more customers knocking on your door than you can take on.

- To become the go-to photographer for the kind of work you love doing.

You know what they say? Happy clients, happy life! Simply put, delivering a five-star customer experience means that you have happier clients. You'll make more money, you'll get more repeat business and you'll get more referrals. If you ask us, that sounds like a pretty good place to be, so let's get it right.

We've already talked about having things in place before and during the Lead Stage, like a killer landing page, an outstanding auto-response, a beautiful 'Thank you' page, follow-up emails, and a way to make sure the process of booking you is super easy. Now let's talk about what happens once your client confirms and actually books you.

Just put yourself in your client's shoes for one second. They want an awesome photographer to capture some kind of special moment in their lives. They've searched long and hard and they've chosen you. There is a period of time between the moment they book and the actual shoot that is very important.

At the time of booking, your client is super excited – consider it a peak of excitement; but that excitement will slowly diminish into regret if you don't continue nurturing them. Your job is to keep those excitement levels high and remind them over and over again that they made the right decision when they booked you. And the best way to do that is with automation.

Referring back to Rick's workflow as a reference, check out all the brilliant things that he does, or to be more specific, that his system does automatically for him, to nurture his wedding couples right up to the day of the wedding.

PRODUCTION

> **Job accepted**
> (ticks automatically when a quote is accepted OR a contract is signed OR an invoice is paid)

☰ **What happens next?**
`Auto send email` `⊙ 1 day after job accepted`

☰ **Thank you for your Speed Date Answers!**
`Send email`

☰ **Photography Timeline Guide**
`Auto send email` `⊙ 7 days after job accepted`

☰ **Bouquet Inspiration**
`Auto send email` `⊙ 247 days before main shoot`

☰ **Vow Booklet Inspiration**
`Auto send email` `⊙ 123 days before main shoot`

☰ **Wedding Cake Inspiration**
`Auto send email` `⊙ 86 days before main shoot`

☰ **Prepare your Family Photo List**
`Auto send email` `⊙ 64 days before main shoot`

☰ **Pre-Wedding Questionnaire**
`Auto send questionnaire` `⊙ 57 days before main shoot`

☰ **Send Photography Timeline**
`⊙ 30 days before main shoot`

☰ **One week before the wedding**
`Auto send email` `⊙ 7 days before main shoot`

☰ **Day Before the Wedding**
`Auto send email` `⊙ 1 day before main shoot`

☰ **Main Shoot**
`Main Shoot`

One day after they book, his system will automatically send his couples an email thanking them for choosing him and explaining everything that is going to happen next.

Seven days after they book, his system will automatically send his couples an email sharing tips about planning the timeline of the day. For example, how much time he will spend with the groom, how much time he will spend with the bride and how much time the couple should allocate to couple portraits after the wedding. It's always nice to check in with your clients, but if you're providing extra value like we're seeing here, you get bonus points! This is really useful information for the couple as they plan their day and decide upon all the other vendors.

Rick's system will automatically send his couple an email,

247 days before the wedding, giving them a whole bunch of different inspirational bouquet ideas. There is actually a link in this email to a specific page on his website which shows heaps of images of different couples, wearing different clothes, in different locations, with different bouquets. This is a brilliant idea helping him to 1) keep in touch, 2) prove that he knows his stuff, 3) give the couple lots of ideas when it comes to styling, dresses, suits, flowers, etc. and 4) get traffic to his website, which improves SEO. Very clever!

The reason for such a random number of days is because he wants to make it as unrecognisable as possible that these emails are system-generated. If emails continue to come out one week, then two weeks, then three weeks in a row, things will start to seem a little too consistent, but if the days are random, the couple may never suspect that these emails are automated. They will think that Rick is sitting there, thinking about them, writing these emails for them because they are important to him.

His system also automatically sends his couples:

- An email giving them vow inspiration.
- An email giving them wedding cake inspiration.
- An email asking them to start thinking about which family photos they would like taken after their wedding.
- A questionnaire asking addresses of where the couple will be getting ready and all the other details about the wedding so that he can put together the final timeline.
- An email one week before the wedding, just checking in.
- An email one day before the wedding, confirming everything and telling them that he's super excited and can't wait to see them tomorrow.

You might be thinking, *That is overkill! Why on earth would you want to reach out to the couple so many times?*

Well, the answer is simple. It regularly reminds the couple that they've made the right decision in booking you. It makes them feel important and loved because you're thinking about them. You're giving your couples important information that they find valuable for planning their wedding. And it puts them at ease knowing that you've got your shit together and they're in good hands.

Exercise: Nurturing with automation

Now think about the types of events that you shoot.

If you shoot family portraits, what could you send your clients to make them feel more loved and nurtured by you? Maybe some outfit ideas. Maybe remind them that they can bring in their favourite toys. Maybe encourage them to bring more people along, like the grandparents, and turn it into a generation shoot.

If you shoot corporate headshots, what could you send your client to get them excited and more prepared for their shoot? Maybe, again, some inspiration for different outfits to wear. Maybe different location ideas. Maybe after the shoot you could send them an automatic email offering them a discount for a family portrait.

The possibilities are endless. When it comes to your specific business and your specific niche, what value could you offer your clients to nurture your relationship? Write these down and set up your templates!

Hopefully this has inspired you to think about different ways you can nurture your clients automatically via email to get them as prepared and as excited as possible about their upcoming photoshoot with you.

But there's more! Sometimes an email is not enough and we need to go above and beyond.

Everything we've talked about so far helps your clients feel valued by you. They trust you and feel like they've made the right decision. Now let's talk about going the extra mile and doing things that not only amplify that trust, but also get your clients raving about you to their friends!

GO THE EXTRA MILE

We want to be refer-able, and maybe we already are by this stage, but there is no harm in going above and beyond. All of the following tips and tricks are things you can do that will absolutely wow your clients and make them love working with you even more.

We want to create situations or experiences that promote word-of-mouth referrals. Just sitting back and hoping that your clients will rave about you to their friend is not enough. We have the power to make it happen, but we need to step up!

Let's rapid-fire a bunch of things that you can start doing that will dramatically move you up the refer-able ladder. Think about implementing them into your workflow.

Send a gift
This tip is tailored more towards wedding photographers but could be applied to portrait photographers too.

Unlike with portrait photography, repeat business doesn't really happen in the wedding world. It's not often that a couple will ask you to shoot their wedding again! But that doesn't mean that we should slack off when it comes to being refer-able. When you really think about it, there is actually a lot of opportunity to get additional business from a wedding. The obvious one is that the couple could refer you to a friend who is also getting married.

Even though weddings are a one-off, you still absolutely want your couples to remember you and rave about you to their friends whenever the topic of 'photographer' comes up.

This is where a little unexpected surprise can go a long way. This little gem has made such a huge impact on Chris's relationships with his clients. He doesn't know how he lived without it.

From now on, every time you book a wedding, wait two months and then send your couple a little something special.

For example, two months after they book you could send your couple a massage voucher with a handwritten note saying something like, 'I know organising a wedding can be super stressful, why don't you take some time out and go and enjoy a relaxing massage?'

OR

Send your couple two gold class movie tickets. They'll absolutely love it! Say something like, 'I know you guys have been so busy organising this wedding. Why don't you go out and enjoy a date night?'

I mean, can you just imagine for a second the surprise and excitement your couples would feel if they received this from you!? It's thoughtful, it's generous and who doesn't love a massage or free movie tickets?

Yes! Doing this does cost a little bit of money. But, personally,

Chris is more than happy to spend $100 (of their $3,000+ package) to surprise his couples with an unexpected 'wow' experience! Doing this will help you stand out from other photographers. And as if your couples aren't going to rave about their experience to all their family and friends!

This is one way to totally become more refer-able. It's a tiny bit of effort and a small price to pay in exchange for the ridiculously good business karma that you'll get in return.

Chris does this for every couple that he books. He simply adds it to his wedding workflow and his system reminds him to do this task two months after the couple book him – easy! He never forgets and the results have been amazing.

Now it's your turn. If you're shooting weddings or portraits, think of something that you can give your clients as an unexpected gift, or simply take Chris's ideas. Send this gift to your clients and see what happens. We guarantee the results will be astonishing.

The next day sneak-peek

Essentially, here, you surprise your wedding or portrait client by sharing a sneak-peek with them the day after the shoot, but, as always, we want to make sure we are creating a refer-able situation.

If we are talking about weddings, we want the couple to upload a few photos to their socials and tag us in them as their photographer. But it gets better. We also want to create a bit of anticipation and let the couple know that we will also be uploading a few photos later in the day to our socials and will be tagging them too.

So, what happens is this. When the couple uploads their

photos, all of their friends on social media will see a sneak-peek of their wedding. The excitement is high and everyone is raving about how amazing their photos are and how beautiful they look. You are tagged in them as their photographer, so now everyone knows who you are too. You can drop a comment in and like other people's comments to stay engaged.

Then, you upload a few photos later in the day to your photography business page and make sure you tag the couple. The couple will comment and share this post and suddenly you have all of those people not only knowing that you were the photographer, but also now seeing your business page and able to browse more of your work.

This is easy to do, doesn't take long and is just another way to make you way more refer-able.

Here are the steps in detail:

Step 1: For this to work, make sure you become friends with your couple on Facebook and Instagram before the wedding day. We would suggest asking for their social handles in one of the auto-questionnaires that you send your clients before their shoot. Then it's done on autopilot.

Step 2: The morning after the wedding (the earlier the better), you need to choose and edit a few beautiful photos that you will email to the couple.

These photos don't need to be too crazy or artistic; they just need to be really nice photos of the bride and groom looking their best. Give these photos a quick once-over in Lightroom to jazz them up a bit, but don't spend too much time.

Once they're ready, email these photos to your client. They

will not be expecting this email from you, so when they receive it, they are going to be absolutely over the moon.

The wording of this email is critical. This email needs to achieve five objectives:

- Congratulate your couple on their wedding.
- Surprise them with a few beautiful, unexpected photos.
- Ask them to upload the photos to Facebook and/or Instagram.
- Ask them to tag you and/or your business page in their post.
- And lastly, let them know that you will also be uploading a photo of their wedding to your business page later that day and you will tag them in it.

Here is an example of the email that Chris sends to his wedding clients:

Hey %client_name%

Wow, what a wedding! I had such a good time! It was so much fun 'working' with you both, and I really enjoyed spending time with your friends and family.

Thank you SO much again for choosing me as your wedding photographer…

…and CONGRATULATIONS on being married!

I've attached a couple of photos for you guys from yesterday looking awesome so you can announce your news to the world right away.

If you use any on Facebook or Insta, I'd love it if you could tag me in it @chrisgarbacz

I'll also be uploading one of my favourite photos from your wedding to the Chris Garbacz Photography

Facebook/Insta page later today. I'll tag you so you know it's online.

Enjoy your first few weeks of married life and I'll be in touch soon when your photos are ready.

Cheers,

Chris

Chris has this set up as an automatic email in his wedding workflow so that 1) he doesn't forget, and 2) he can send this email with a click of a button.

Step 3: Now, the final piece of the puzzle!

Choose a few different photos that you will upload to your socials. Again, give them a quick once-over in Lightroom so they look really good.

Later in the day go to your Facebook/Instagram business page, upload the photos and write a really nice post about the wedding. Make sure you tag the couple, as well as the venue and any other suppliers who were there.

On Facebook, you can actually schedule this post to go out later in the afternoon. Click on the schedule button and choose 4pm.

That's it, you've nailed it!

Now just wait for your couple to upload their photo to Facebook/Insta. Your scheduled post will follow. You can just sit back, relax and watch all the comments start rolling in about how amazing the couple look and how beautiful their photos are.

This is a really great and easy way to let every guest, as well as all of the couple's friends, know who the photographer was. Best of all, it's free marketing!

If you're a portrait photographer, you can also implement this strategy. Just be careful, because if your business model is to sell photos after the shoot, you don't want to give away too much. Sending low-res, watermarked photos will protect you too.

On to the next one.

Get vendors in on the action

It's time to rocketship the previous idea to the next level. There are a lot of pieces that need to come together for a wedding to be successful. Think about all the vendors involved – for example, the reception venue, florist, dressmaker, the band, the MC, the celebrant and the list goes on.

These vendors have a problem because they are always looking for and scrambling to get content for their socials. Now imagine that you are the solution to their problem, because you are going to give them these photos and they are going to share your photos with all of their audiences too! Boom, happy vendors and free advertising.

Ideally you have an automatic questionnaire that goes out to the couple before their wedding day asking them who all their vendors are. It's even better if you get their social handles too. If this happens automatically, you'll never need to worry about it or remember to do it again.

And because you had this strategy in mind while you were shooting the wedding, you will have made a point of spending an extra minute here or there getting some specific shots not only for the couple, but for the suppliers too.

So, now that you've got the photos and you've got the suppliers' details, it's time to put two and two together.

Go through all the photos from the wedding and pick out

a few for each supplier. A few beautiful photos of the bride for the makeup artist, a few beautiful photos of the bouquet for the florist, a few beautiful photos of the cars for the car hire company. You get the idea!

Give those photos a quick once-over and when they're ready, send them to each supplier. Two things will happen:

1. They will post these photos to their socials and mention or tag you in them as the photographer. Their whole audience, including couples getting married in the future, will see your work and pick up on the fact that you were the photographer.

2. You will start forming a relationship with these vendors. You're making an effort to supply them with photos that they need, you're reaching out to them, you're being consistent, reliable, and you are becoming someone they can trust. You are becoming refer-able!

So, not only are you getting free advertising from the vendors sharing your photos with thousands of people in their networks, but you're also building and strengthening your relationships with these vendors. It'll only be a matter of time before they are referring you to their clients too!

If you shoot family portraits, you could totally use this strategy too. For example, maybe your niche is cake-smash photoshoots or maybe you use cute doggy toys during your pet shoots.

Why not share these photos with the suppliers? They are always looking for content and if the photos look awesome, they'll be happy to share these photos on their socials. It's a great way to get your name out there.

Have a good think about the type of photography you do

and see if there are some vendors involved that you can bring in on the action. Share your photos with them.

Quick turnaround

We are constantly on a mission to exceed our client's expectations and another way we can do that is to work quickly. There is no secret sauce to this one. No tips or tricks. We just need to do the work we were always going to do, but quicker. And by quick, we're talking fourteen days or less.

Now, before you start freaking out, think about it. How much work is really involved in turning around a wedding, for example?

You need to:

1. Cull the shoot to the best X-amount of images that you would normally deliver (one to two hours).
2. Edit all these photos (four to eight hours) OR you can outsource this process, which we'll talk about a little later.
3. Package the photos up ready for delivery and create an online slideshow for more wow factor (one to two hours).

We've often heard stories of photographers taking two or even three months to get a wedding back to a couple. In our opinion this is completely unnecessary and possibly even a little lazy. If you're going to take three months to deliver a wedding, you are barely meeting your couple's expectations or, worse, you are making them frustrated having to wait so long. It doesn't need to take that long! You just need to put some time aside and prioritise this task over others that are not as important.

Imagine what your couples would say if you originally set the expectation of one month but then after just ten days, you emailed them saying something like, 'I've been working really

hard on your shoot because it was sooo good and now your beautiful photos are ready for you!'

Chris has been doing this for years now and every time his couple receives their photos early, they are completely taken by surprise (again). They are so happy and thankful and they have another reason to rave about him to their friends.

Remember, your couples are still at their peak of excitement after their wedding. They may even still be on their honeymoon or have just got back, so if you can deliver their wedding photos as quickly as possible, they will be completely blown away. Another tick on the more refer-able scoreboard!

This also applies to portrait photographers. If a family has an amazing photoshoot experience with you, they'll be dying to see their photos as soon as possible. Don't leave them hang-ing too long! Your client's excitement level will slowly fade with every passing day, which also means your chances of selling more products is dwindling too. Get these people back into your viewing room as soon as possible so that they're making their buying decisions while they're still excited. Wait too long and you might be eating baked beans for dinner.

GET PAID, WHILE YOU SLEEP!

After implementing all these strategies you'll become so refer-able that you will have leads knocking down your door. So, let's jump back into some productivity hacks. Here you will learn a few more tips and tricks on how to streamline and automate your processes so that you can easily scale up.

Let's talk about getting paid, the best part of the job, right?

Wrong! Here's a story of how this used to go down for Chris back in the day.

He was shooting about fifty weddings a year and each wedding was split into three payments: a thirty-three percent deposit, a thirty-three percent payment due roughly at the halfway mark, and the final balance due just before the wedding.

Now, in hindsight, Chris has no idea why on earth he decided to make his life hell by structuring his client payments this way. It was an absolute nightmare to manage.

Firstly, his calendar was completely full, with 150 reminders throughout the year! Every day or two, a notification would ping saying 'Invoice Jenny and Matt 2nd payment'. Or 'Invoice Lucy and Greg 3rd payment'. It was never-ending and often Chris would get side-tracked at the time of the notification and just forget.

Secondly, thirty-three percent equals a random amount. Chris would be sending invoices for $1,154.67. That's such a random number! Often clients would get back to him asking, 'Is that actually the correct amount or just a typo?' Or they would round the amount up or down and send an amount of money that was totally different from the invoice amount. Then Chris couldn't reconcile the payments because they didn't match up with the invoices. *Argh!*

And thirdly, the icing on the cake. This is the thing that tipped him over the edge. Imagine what happened when clients forgot to pay… Tracking everything and everyone through a spreadsheet and marking off who did pay and didn't pay was a killer, and so was having to follow up with an email saying something like:

Hey Jenny,

It's Chris here. Sorry to bother you, but ummmm, did you receive my last invoice? Don't worry, no rush, I know we're all busy, but I just wanted to make sure you got it...

Let me know.

Cheers,

Chris

It was awkward and uncomfortable, and Chris always felt like he was harassing them. And if they still didn't pay, he thought he was going to have a heart attack because he simply didn't know how to handle it. Were they ignoring him? Were they refusing to pay? Had they cancelled their wedding? Did they no longer want Chris to be their wedding photographer!?

When it comes to payments, no questions asked, this is an absolutely critical part of your business that you need to have a system in place for. Doing it manually is so unnecessarily time-consuming and stressful.

Imagine how relaxed your life would be if invoices were automatically generated from quotes, if clients could pay you via credit card while you slept, if reminders for overdue payments could be sent out automatically while you're chilling out and knocking back a few beers! That is exactly what a system like Studio Ninja is designed to do. It will even automatically send a receipt to your client as soon as you get the payment. You barely have to do anything. So, get organised and make sure you have something like this in place or, at the very least, accounting software to handle this part of your business for you.

HANDING OVER THE REINS

Okie dokie, we're down to the home stretch, and we've left some of the best stuff till last. If you really want to scale, we've got three more productivity hacks for you that will completely change the way you run your business and free up your time, forever!

As you know, running a photography business isn't all fun and games. You love shooting and being creative but in reality there are a million other things that you also need to do to keep your business up and running. Things like all the admin, accounting, editing, marketing, website design, SEO, and the list goes on and on.

Of all the things that you do to run your business, have a think about where you're spending the majority of your time…

How painful are some of these tasks? Are you efficient when you do them? Could your time be better spent doing other, more important tasks in your business? Or maybe if you had that time free, you could spend more time with family and friends or even on yourself, doing something that you love to do.

This section of the step is all about handing over the reins, also known as outsourcing.

Do, decide, delegate or delete

Jeff Bezos is the founder, chairman and CEO of Amazon. In 1994, he started Amazon as an online bookstore and grew it into the world's largest online sales company. Today it is also the world's largest provider of cloud infrastructure services.

You may think he's one of those CEOs, like Elon Musk, founder and CEO of Tesla, who suggests the only way for entrepreneurs to succeed is to work at least eighty hours every week. But, in

fact, Jeff does the opposite. Despite running one of the biggest and most valuable companies in the world, he is famous for championing the importance of establishing 'normal' routines.

He's said, 'I go to bed early and I get up early. I like to putter in the morning. So, I like to read the newspaper. I like to have coffee. I have breakfast with my kids before they go to school.' His advice for entrepreneurs is to set their first important mental challenge at 10am in the morning. 'I do my high-IQ meetings before lunch. Like anything that's going to be really mentally challenging, that's a 10 o'clock meeting. And by 5pm, I'm like, "I can't think about that today. Let's try this again tomorrow at 10am."'

Successful photographers know how to manage their time well. Everyone has the same amount of time in a day, but when you manage your time well, you become far more productive and can achieve a lot more than the average person.

Think back to the challenges we talked about in the introduction. 'I don't have time' is one of the catchcries of the modern world. But what we're really saying is that we have different priorities. Think about the things you do day to day. There's always time for some things. That's because we *make* time for them. They are our priorities. We all have the same amount of time in the day, but we all prioritise our time differently. We're constantly deciding how to spend our time and devoting it to different things. Making this process conscious and deciding what we actually want to do with our time and where we really want to save time can be revolutionary.

Dwight Eisenhower, the thirty-fourth President of the United States, said, 'What is important is seldom urgent and what is urgent is seldom important.' Think about all the demands on

your time. Some of these things seem urgent – perhaps someone is chasing you for something. But in terms of your overarching goals for yourself and your business, some of these urgent things just aren't important. The time you spend on them is not going to help you reach your goals, but because the important things don't have that sense of urgency attached, they always get pushed to the back of the queue rather than prioritised as they should be.

One way to be more productive and stop wasting time is to use the 'Eisenhower Box'. Categorise the tasks you have ahead of you by importance and urgency. If something is both urgent and important – just do it. If something is important but not urgent, decide when you're going to do it and schedule that time in. If something's really not that important when it comes to the big picture but is an urgent task that requires doing, then delegate it – figure out who or what can do it for you. And if something you always seem to be able to find time for is neither important nor urgent, then simply delete it – free up that time.

	URGENT	NOT URGENT
Important	**Do** Do it now. Write blog article today Apply for an award which is due this week	**Decide** Schedule a time to do it. Create marketing plan Set up templates and workflows Exercise
Not Important	**Delegate** Who can do it for you? Editing photos Bookkeeping Uploading photos to socials	**Delete** Eliminate it. Check social media to see the number of followers and likes Sort through junk mail

Exercise: Delegation

..

When it comes to delegation, a great way to approach this is to write yourself two to-do lists. Here's a swift example:

TASKS TO ELEVATE	TASKS TO DELEGATE
These are tasks you need to do more of. Become better, faster and more productive at them. Mastering these tasks will generate more clients and sales.	These are tasks that you can teach someone else to do or set up a system to manage. If you keep spending time on these tasks, you will never have enough time to spend on the more important stuff.
Shooting	Retouching photos
Marketing	Answering emails
Delivering the best customer experience	Admin (e.g. chasing up contracts and invoices)

So, take out your pen and pick up your paper and write yourself two lists right now. What are your tasks to elevate? And which ones could you delegate?

Now, we know, you're probably freaking out right now. How could you possibly hand over some parts of your business to someone else!?

Your initial thoughts might be:

1. How could someone else possibly do it as well as me?
2. I've heard horror stories of outsourcing going terribly wrong.
3. I can't afford it.

All very valid thoughts, but just stick with us for a second and be open-minded. We're going to share three different stories

with you that might inspire you not only to consider outsourcing, but to start embracing it too!

When Chris originally did this exercise years ago, someone asked him, 'Chris, what tasks do you do in your business that you really don't enjoy and how time-consuming are those tasks? If you weren't doing those tasks, what would you do instead?'

Instantly, like a bolt of lightning, three tasks came to mind. The answer to that question was so obvious. And the first task we're going to talk about is culling and retouching.

Culling and retouching

Now, Chris started his career as a retoucher and he was good at it. He also felt like retouching his own work was part of the creative process. At the time of taking the photo, he had the vision and only he would know how he wanted the final image to turn out.

But as a couple of years went by and he photographed more and more weddings, he started noticing a couple of subtle changes occurring:

1. His retouching style became very similar from wedding to wedding.
2. Retouching went from being fun, an expression of his creative freedom, to actually being a bit of a repetitive, mind-numbing chore.

Chris would walk into his office, notice a backlog of weddings building up waiting to be retouched, and he would procrastinate. There was always something more urgent that would take priority, so he would just put the retouching on the backburner, again and again, day after day.

He knew he couldn't put this off forever – couples were

chasing him up: 'Chris, it's been three months, where are our wedding photos? Have you lost them?!' Things were getting tense.

To get himself in the zone, he would listen to the *Rocky* soundtrack on the way to work. He would walk into the office, pumped, bouncing up and down, ready to jab, cross and uppercut his way through the ever-increasing pile of backlogged weddings.

Cup of coffee in hand. Lightroom open. *Here we go, let's crush this wedding,* he would think to himself.

And boy was he in the zone! He was flying, retouching image after image. He was concentrating hard, focused, determined. He was fighting hard, fighting to stay in his Zen flow state. He knew what would happen if he got distracted, even for a second…

And then thirty-seven minutes into his mission, a thought popped into his head. *Hmm, I could really go for another coffee right now.* Time for a break. Uh oh. It had begun!

Back to retouching and halfway through his coffee… *Hmm, I'm kinda hungry, maybe I'll quickly go to the fridge and whip something up.*

An empty coffee, and half a sandwich in hand, he's back retouching. Five minutes later, he pauses to ponder. *Hmm, did I just notice that my fridge was dirty? It could really use a clean.*

And just like that, the *Rocky* soundtrack was out of his head, his motivation had evaporated and before he knew it, he was full, overly caffeinated, his fridge was clean, his house was clean, his dog had enjoyed his third walk for the morning and he'd even spent a bit of time watching the grass grow.

It got to a point where he just couldn't do it any more. He was unconsciously prioritising time to watch the grass grow over tackling the pile of unretouched weddings. What used to take him

three hours was now taking him days. Something had to be done.

It was time to hand over the reins.

Chris was scared. He was worried. He had all the concerns that we mentioned earlier. What if they stuffed it up? What if it was more trouble than it was worth? Could someone else actually retouch as well as he could? Well, the reality was that he was currently avoiding it like the plague, so it was time to give it a try.

Chris reached out to three different retouching companies: one in the UK, one in Canada and one in Australia. He was pleasantly surprised by 1) how amazing their websites and before/afters looked, and 2) how quick and professional they were in getting back to him.

The process with all three turned out to be painless and, actually, quite enjoyable. The onboarding experience was brilliant. He scheduled a Zoom call with each of them and right there, right in front of his eyes, they would retouch his photos live on the call. They did their homework, they did their research, they knew his style, they were prepared and, as hard as it is for Chris to admit this, they were better than him too.

It was a done deal. Chris felt like he had just discovered the Holy Grail. Why hadn't he thought of this before? Why did he put himself through all that pain, for so long?

After two or three weddings and a bit of feedback from Chris, they were nailing it. At $150 a pop, these guys were smashing through his pile of backlogged weddings. The photos were looking better than ever, clients were getting their photos back in weeks, not months, and that dreaded pile... was no more.

Chris was reinspired to shoot weddings again. A new flame had sparked inside of him. He had a second wind to push his business to the next level. He started realising the possibilities

of what he had just discovered. If he didn't have to spend a day or two retouching any more, what could he do with all that extra time? What would you do if you could free up a day or two of time? Have a think about it.

Maybe getting someone else to retouch your work could save you as much time and stress as it did for Chris.

 Rick Liston on outsourcing:

I'm happy to tell you right now, that's the one thing that I wish I had done sooner – going down that outsourcing process. When you start, I'm sure everyone's the same, you want to do everything yourself, build your own website, do your own branding, make your own logo, do your own accounting. And I don't think it was until after I started doing it that I appreciated it – particularly outsourcing editing.

Obviously, that's the first thing that you can do, where just with a tick of a box you can basically free up a whole week of your time. And that's time that you can either spend shooting later, earning that $500 per hour that you're so good at, or spend with your family doing something you love, or spend working on your business, making sure you're getting more leads. And so, by choosing to edit them yourself, I really feel you're actually costing yourself a hell of a lot more than you're gaining.

Number-crunching

Chris's second epiphany came during tax time. Now, we don't know about you, but Chris wasn't very good at staying on top of

his books. He had receipts in his pocket, in the car, in his drawer… his kids were probably making paper aeroplanes out of them too!

Chris noticed that every three months, when it was time to get on top of his books, a vein would pop out the side of his neck and a bead of sweat would appear on his forehead. That dreaded tax time.

What was that expense for again? What did he buy last Thursday? Where did that receipt go for the new camera he bought last month?

There are some things that he was put on this earth to do and he could do them all day long, like shooting, for example. That puts a smile on his face and brings him joy. And then there are some things that he was put on this earth to avoid like the plague, like retouching… and bookkeeping!

It would take him hours and sometimes days to reconcile all his income and expenses. As with retouching, Chris was experiencing the same levels of anxiety and dread and hatred towards bookkeeping. Something had to be done. And just like retouching, outsourcing was the solution.

At $30 per hour or roughly $100 per quarter, this was an absolute no brainer. A bookkeeper set up Xero and asked Chris to take photos of his receipts. That's it. There's nothing more to say, because it was literally as easy as that. Chris never had to worry about tax time again and could tick another headache-inducing task off his list to free him up to do more important things like working on his business or playing with his kids.

Do you still do your own bookkeeping? Do you enjoy it or does it make your blood boil!? If you're not a number-crunching machine, then maybe it's time to hand over the reins to someone who is.

The VA

Up to this point, Chris thought he had everything worked out. He had created a marketing machine and a system that was nurturing his clients and doing all the things that he no longer wanted to do, almost totally on autopilot.

Before he had put all these new things in place, he was spending about ten percent of his working time actually shooting, which is what he really wanted to do, and the rest of the time working IN his business. Now, he had a system in place, and he was able to spend more time shooting, which he loves. He also had the mental space to spend more time working ON the business and on himself.

It was the first time since starting his photography business that he was actually able to allocate some time to himself and his wellbeing and it felt great. He took up CrossFit, running, kitesurfing, mountain biking and yoga. He was able to rest during the week, recharge his own internal batteries and get excited about his next upcoming shoot.

No longer exhausted and burnt out, he was also able to rock up to a wedding full of life and on the ball. As we mentioned earlier, he had a new flame inside of him and was totally reinspired to get his creative juices flowing again. He felt like couples were getting a well-rested, fully invigorated, full-of-beans version of Chris, rather than an exhausted, depleted, half-assed version.

He felt like he was coming out on top, but there was still one more thing bothering him and he couldn't quite put his finger on it. Chris revisited his whole workflow and analysed each step of the process, internally thinking to himself, *Is this part running as efficiently as it could?*

There isn't a sob story here. The truth was that, yes, almost all parts of his workflow had been revised and improved and were working really well.

Everything except some of those admin tasks that he was still doing manually. Specifically, some of those tasks that we mentioned in the section on going the extra mile. The ideas were brilliant and they were working really well, but Chris was still spending a lot of time on them.

Things like:

- Sending a gift to couples
- Preparing photos for the next day sneak-peek
- Doing the social media stuff
- Preparing and emailing all the photos for the vendors
- Culling
- Sending photos off to the retouching company
- Preparing slideshows

You get the idea. These things still ate up a lot of Chris's time, so the question was: Did he really need to be doing this stuff too?

The answer was no, he could definitely hire and train someone else to do those tasks.

So, that's exactly what he did. He spent some time hiring and training a VA (a virtual assistant, let's call him Bruce), and getting him up to speed on all his processes. We're not going to lie, this wasn't as easy as hiring a retouching company, but Chris thought of it as an investment. It was either him doing all these tasks all the time, ongoing, forever, or he could spend a little bit of time now, training Bruce up so that he could take all these things off Chris's plate.

Again, it was a huge success. Once Bruce was up and running,

Chris started handballing him more and more tasks until, eventually, he was doing them all better than Chris!

So, we're going to ask you one last time: Do you enjoy doing these administrative tasks in your business? If so, great! Absolutely keep doing them. But if not, maybe you should think about hiring a VA as well.

Here's where we leave Chris – with more time on his hands, less stress on his plate and a superpowered photography business that has him earning more and doing what he loves. This is a direct result of following the four steps we've told you about in this book. We're convinced they can help you as much as they've helped Chris, which is why we decided to get it all down. We hope we've given you something to think about!

SHOOT LIKE A NINJA: STREAMLINE, AUTOMATE AND OUTSOURCE

This last step has been about reclaiming your time, reducing your stress and getting back to what you love. Here's the quickfire key points to consider and come back to in this chapter:

- Wherever you can, use templates to save yourself time when communicating with customers at various points along their journey with you.
- Employ automation to help nurture your clients, setting yourself up as one of their most helpful resources before you've even taken a shot, reminding them why they booked you and giving them confidence you'll turn up committed and prepared on the day.
- Go the extra mile and prove that you're thinking about them as people, beyond just being a paycheque.
- Make getting paid as easy and straightforward as possible by taking advantage of your photography business app or using accounting software.
- Figure out what you can delegate, and take the leap into outsourcing to free up your all-important time. Then you can dedicate that time to the parts of business and life that are most important to you.

Conclusion

It's time to get out there and shoot like a ninja!

Think back to the problems and mistakes we talked about in the introduction – the minefield of challenges today's photographers face.

Many photographers worry they're not making enough money. Remember, it's not a sprint; it's a marathon. Generating sales and revenue that are consistent and sustainable requires commitment and planning. Practice makes perfect! With stronger brand recognition, customer loyalty and a focused strategy to close deals, you can price profitably, confident in the fact you're recognised in your niche as your ideal clients' go-to photographer.

Other photographers are plagued by self-doubt. Victims of impostor syndrome and sufferers of 'comparisonitis', they're focused on the achievements of others over themselves. The important thing is not to listen to that negative voice in your head telling you you're not good enough. Maybe you do lack some business skills, maybe accounting, sales and marketing are not your forte, but that's why it's important to recognise the value of the tools, technology and technical experts out there that can help you. You don't need to do it all to be at the top of your game! And you don't need to be doing what everyone

else is doing – work on your own story and uncover your own chance to shine.

If you didn't know before how valuable it is to have a niche – you do now. You can't be everything to everyone. You just end up spreading yourself too thin and doing a lot of things well rather than specialising and standing out for doing certain things spectacularly! That's how you become the first choice for your ideal clients.

Those photographers who struggle because they don't have a system are the ones who will one day drop the ball. There's too much to handle and it's all in your head – when your brain gets overloaded and overwhelmed, that's when you're at risk of burnout, which can strike down the best of us. A great system that's got your back is not just a safety net but a springboard that can send you to new heights. Remember, it's not just about integrating the right software into your daily to-dos – you have to change your thinking too. It's time to adopt a systematic approach to your photography business.

As the saying goes: if you fail to plan, you plan to fail! If you're batting balls as fast as they fly at you and working on a client-to-client basis without an eye on the future, you won't be sustainable in the long run. You'll be one of those photographers prioritising and spending their time on the non-urgent and unimportant tasks, or even the urgent but unimportant tasks, not in control of the elements that could change everything for the better. Creating a plan doesn't have to be a complicated, time-consuming process, but with simple goals, set out in a helpful way, and a method for checking in on the actions required and the progress being made on those goals, you can go a long way.

This book has aimed to face these challenges head on and

offer tools and guidance to correct the mistakes. The four steps are a way to approach your photography business with renewed enthusiasm, embracing a laser-like focus and a step-by-step strategy.

In *Step 1: Craft your niche*, we talked about the benefits of finding your spot in the market and specialising. Communicating your values through your story and embracing your brand archetype, you looked at drilling down on the idea of your ideal customer and creating a persona for them. Then you came up with ideas for niche products or experiences they'd love, before turning to build recognition in your field through testimonials, awards, speaking or teaching. Remember that standing out doesn't mean standing alone – it's important not to isolate yourself, and finding your community can boost you up as well as your business!

In *Step 2: Campaign and attract*, we got into the all-important planning. Setting SMART goals and coming up with a simple marketing plan, we turned to building your website around your ideal client and utilising well-presented landing pages. We talked about products and packaging before looking at growth, offering guidance on scaling your photography business with gift vouchers and referrals.

In *Step 3: Convert and close*, we addressed how to easily convert leads into paid jobs, automatically capturing leads using a photography business app or studio management software. Where you send your potential clients after they have enquired is as important as the initial enquiry, so we turned to sprucing up your 'Thank You' page and creating a standout auto-response. Then we looked at the difference that a detailed workflow can make to your business, helping you manage your leads, while

setting up your app to send quotes, contracts, questionnaires and invoices as efficiently as possible.

In the final step, *Step 4: Streamline, automate and outsource,* we looked at ways to become even more efficient, utilising templates to save time and capture important information. Going through ways to nurture clients by employing software automation, we then turned to going the extra mile, with ideas that attract those rave reviews, repeat bookings and recommendations. There is so much to do. In the closing sections, we talked about making it easy to get paid and considering that daunting prospect – handing over the reins and delegating tasks to others so you can get on with what you're best at and enjoy most.

We don't see this book as a 'one and done'. Come back to the bits that can help you build your business, redo the exercises, revisit the perspectives of the profitable photographers who've made it all work for them – and be inspired.

You now have the tools to transform your photography business. Remember to constantly measure your progress so you can improve your processes. And keep innovating!

4 STEPS TO WORK LESS, EARN MORE AND SUPERPOWER YOUR PHOTOGRAPHY BUSINESS

1. CRAFT YOUR NICHE

- Discover your niche to stand out from the crowd
- Tell your story to communicate your core values
- Consider your archetype to help build your brand
- Identify your ideal customer to create a customer persona
- Develop your product niche to offer something out of the ordinary
- Build recognition through winning awards, getting published, running workshops and speaking at events
- Find a community that supports you and sets you up for success

2. CAMPAIGN AND ATTRACT

- Set SMART goals to make your objectives manageable and meaningful
- Create a simple marketing plan by setting annual and quarterly targets
- Identify the channels to focus on and don't put all your eggs in one basket
- Build a results-driven website that makes your ideal client feel at home
- Design amazing landing pages that match up with your marketing
- Price your products appropriately and decide whether packaging is right for you
- Scale your photography business with gift vouchers and referrals

3. CONVERT AND CLOSE

- Automatically capture leads to remove the admin and save you time
- Have a 'Thank You' page your lead goes to after giving you their details
- Create an auto-response that shows your personality and offers value
- Use a workflow to manage your leads and ensure the key tasks and milestones of your process are in there
- Use a photography business app to send your quote, contract, questionnaire and invoice quickly and easily

4. STREAMLINE, AUTOMATE AND OUTSOURCE

- Use templates to save yourself time when communicating with customers
- Employ automation to help nurture your clients, setting yourself up as one of their most helpful resources before you've even taken a shot
- Go the extra mile and prove that you're thinking about them as people, not just a paycheque
- Use a photography business app to get paid easily
- Figure out what you can delegate, and start outsourcing to free up time
- Dedicate that time to the parts of business and life that are most important to you

Connect with us

🌐 studioninja.co
📕 Studio Ninja
📷 @studioninjacrm

STUDIO NINJA

Built for photographers, by photographers, Studio Ninja is the world's highest rated studio management software.

Extremely user-friendly, it takes less than thirty minutes to set up. Increase your bookings with customisable workflows, automated emails and easy payment plans.

TRY STUDIO NINJA'S FREE THIRTY-DAY TRIAL!
Head to www.studioninja.co

Resources

Podcasts

- The Smart Passive Income podcast by Pat Flynn: https://www.smartpassiveincome.com/podcasts/ no-ideas-no-expertise-no-money-business/
- The Starting from Nothing podcast by The Foundation: https://thefoundation.com/podcast/
- The Photo Biz Xposed podcast by Andrew Hellmich: https://photobizx.com/photography-podcast-player/

Books

- *Key Person of Influence* by Daniel Priestley
- *Archetypes in Branding: A Toolkit for Creatives and Strategists* by Joshua C. Chen and Margaret Hartwell
- *Zero to One* by Peter Thiel
- *The 10x Rule* by Grant Cardone
- *The Conversion Code* by Chris Smith
- *Expert Secrets* by Russell Brunson
- *Atomic Habits* by James Clear
- *Hacking Growth: How Today's Fastest-Growing Companies Drive Breakout Success* by Morgan Brown and Sean Ellis

Web

- Wedding Workflows by Rick Liston:
 https://weddingworkflows.com/
- Pixellu: https://www.pixellu.com/blog/
 landing-pages-for-photographers
- Flothemes: https://flothemes.com/

Acknowledgements

The biggest thanks to our family and friends. Yuan would love to thank his husband, Steve, brother, Choon, Mum and Dad, sisters Sze Min and Ing. His friends Kenneth, Damien, Luke, Jane, Deanne and Julia. And his mentors Chris, Aaron, Glen and Jo. Chris would love to thank Mum and Dad, the kids, Lily and Flynn. And his friends Mark, Rick, Callum, Clint, Neil and Natalie.

We want to thank our amazing team, Sally, Nikki, Ric, Jan, Elle, Woody, Tannia, and our talented engineers at Sombra. And the incredible photographers we've met through our business and who have added to this book in many ways – thank you for contributing your time, experience and incredible stories: Alan Law, Alex Cearns, Andrew Hellmich, Anna Hardy, Anna Pumer, Ben Sowry, Chad Winstead, Chris Scott, Danilo and Sharon Vasic, Erika and Lanny Mann, Joel Alston, Kate and Brent Kirkman, Kristen Cook, Liam and Bee Crawley, Lisa Devlin, Mark Rossetto, Rebecca Colefax, Rick Liston, Sam Docker, Scott Johnson, Tim Williams and Tommy Reynolds.

Finally, thank you to our early adopters, our seventy champion users – you know who you are. Our earliest adopters paid for Studio Ninja when there was no product. They believed in our vision and helped fund our idea. Thank you for believing in us and seeing our potential.

About the authors

Chris

Chris Garbacz is an award-winning wedding photographer and co-founder of Studio Ninja.

Since starting his photography career in 2007, Chris has been passionately photographing families and couples, producing actor headshots, working with commercial projects and fashion labels and – now his favourite genre – photographing weddings. Since niching down to focus primarily on weddings, he has had the privilege of travelling around Australia and New Zealand photographing beautiful weddings for over 500 loved-up couples.

In 2015 he co-founded Studio Ninja, a photography business software and mobile app that has helped thousands of photographers across seventy-two countries. Studio Ninja helps photographers to streamline their business, eliminate paperwork and get their time back.

When he's not busy juggling two businesses or wrestling with his two little kids, you'll find him telling stories around a campfire, kiteboarding in the bay at sunset, exploring the wilderness on his mountain bike, lifting something heavy at his local CrossFit gym or battling a mate in a game of chess.

Yuan

Born in Johor Bahru, Malaysia, Yuan crossed the border every day to go to school in Singapore throughout his formative years. He moved to Australia at the age of eighteen and graduated with a Bachelor of Design (Honours), followed by an Advanced Diploma in Photography. A proud member of the LGBTQ community, he now resides in Melbourne with his husband, Steve, and his brother, Choon.

A multi-award-winning art director, user experience (UX) designer and photographer, Yuan has over fifteen years of experience in interaction design, having worked with many international and Australian organisations.

After a brief stint in advertising, he left a lucrative management role to focus on the not-for-profit sector by founding Yump in 2013. Yump is a UX design agency specialising in creating websites for not-for-profit organisations and social enterprises. While searching for a co-working space for Yump, he met Chris. They met up for a coffee to talk about an idea called Studio Ninja, and the rest is history.

Yuan is passionate about creating customer experiences via lean UX and co-design principles. He enjoys speaking and sharing about UX and start-ups at conferences, technology meetups and in entrepreneur communities. When he's not busy running two growing companies, he is a keen CrossFitter, daydreamer, foodie and bi-weekly cook with a penchant for Southeast Asian cuisines.

Lightning Source UK Ltd.
Milton Keynes UK
UKHW011609061221
395183UK00001B/22

9 781989 737422